IMAGES
of America

HUDSON

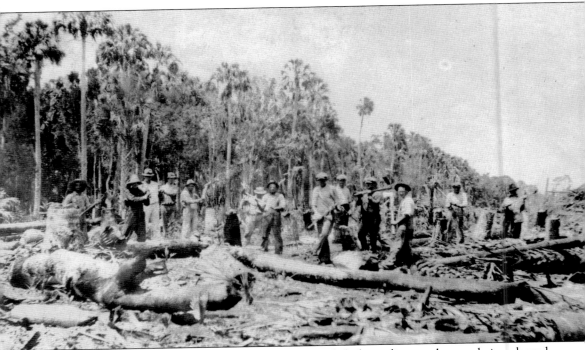

Early land clearing often took days or weeks to accomplish depending on the area being cleared. Without the aid of heavy equipment, the only means to clear land was to gather a group of the local men to assist in the work. The men would work in stages, first cutting the trees down, followed by clearing the cut trees, and finally digging out all of the roots and stumps. This was the same process for clearing roads, railroads, and farmlands. This photograph may in fact show clearing for the early Dixie Highway north of Hudson. (Brenda Knowles.)

ON THE COVER: Titled "Spring-Boat Fishing at Home," the photograph of this spring, now called Hudson Spring, shows the location where Bear Creek emptied into the Gulf after flowing underground for 2 miles. After purchasing 200-plus acres, the Hudson family hired survey crews to plat a new town site. With their tents pitched along the banks, it appears that crews are standing with their equipment and ranging rods, while John and Joseph Hudson are believed to be on the boats. (Camille Coors.)

IMAGES
of America

HUDSON

Jeff Cannon

ARCADIA
PUBLISHING

Published by Arcadia Publishing
Charleston SC, Chicago IL, Portsmouth NH, San Francisco CA

Printed in the United States of America

Library of Congress Control Number: 2009921904

For all general information contact Arcadia Publishing at:
Telephone 843-853-2070
Fax 843-853-0044
E-mail sales@arcadiapublishing.com
For customer service and orders:
Toll-Free 1-888-313-2665

Visit us on the Internet at www.arcadiapublishing.com

*This book is dedicated to the courageous pioneer men
and woman who sought to make Hudson a better
place for all residents and not themselves.*

CONTENTS

ACKNOWLEDGMENTS

It is impossible to name everyone who contributed over the years, but I offer the greatest amount of gratitude to those who not only shared their amazing photograph collections but offered their interest, insight, support, and willingness to aid in the preservation of Hudson's almost forgotten past.

I'm truly indebted to Brenda Knowles, the great-great-granddaughter of William Graham Frierson, who graciously shared her family's amazing photograph collection of more than 100 years. Brenda has offered support and assistance not only in this publication but with the years of historic research that I have compiled. Without her family-like support, this publication may have never been.

I am also greatly thankful to Ann Knowles, daughter of Jack Henry and Annie Christie Knowles, for her sharing and time to answer my many questions; to Camille Coors, descendant of the Hudson family, for her family knowledge and rare photograph collection; to Maranell Baker Fleming for her support and Hay family photographs; to Hilma Sue Lysek Tracey for taking time to gather Lysek and Littell family photographs from family such as Kay DeCubellis Waddell, who graciously shared her collection; to Calvin and Susan Hatcher, Geraldine Hatcher Dougherty, and Alice Hatcher for their Hatcher collections and area knowledge; to James and Delores Fortner Sanchez for their wonderful school and church photographs and insight into these early institutions; to Jim Lang for his detailed family research; to Ora Lee Littell for sharing the Mayhew E. Littell Collection; and finally Sandra DeLeo, the author's cousin, for sharing her information on the Ryals family.

I also want to acknowledge my parents, Danny and Barbara Cannon, for their support and patience in my historic research, preservation work, and historic Web page www.pascocemeteries.org. I also want to acknowledge my grandmother, Nita Rewis McCulty, for her support and generational knowledge of the Hudson area and our family who settled here in the late 1870s.

It was the greatest honor working with such a group of passionate and knowledgeable people, most who have been blessed with the greatest privilege of descending from original pioneers of the great Hudson community.

Unless specifically credited otherwise, all photographs are courtesy of Brenda Knowles. Brenda also made available the many collections provided to her over the years: New Port Richey Press research at West Pasco Historical Society and the Dade City Banner at Hugh Embry Library.

INTRODUCTION

With the blaring sirens of fire trucks and ambulances speeding down U.S. 19, it is certainly hard to imagine a time when Hudson had no sirens, cars, or huge subdivisions where almost everyone now lives. Today in our busy lives, we seldom sit back to look around, think, and picture how it might have looked "back then." Historically speaking, Hudson is relatively young, being only 140 years in the making. Few know of any history before Hudson while some only know of how Hudson came to be named. If one could travel back 150 years, he might come face to face with the Seminole Indians who sought the coastal waters for food, settling peacefully along today's Old Dixie Highway. As recently as 1855, it has been documented that Pasco County was still visited by the elusive Seminoles. Throughout the area are the remains of the once thriving village campsites that were occupied by these original settlers. Today these early villages lie obscured, only evident through the occasional burial mound or mere pile of oyster shells, byproduct of a staple food. While an entire chapter could be dedicated to the rich history of the Native Americans around Hudson, this publication will highlight the time period when our first pioneer families arrived, establishing parts of the community known today.

After the Civil War, Hudson received the first permanent white settlers; however, during this time, the area was still without a name and resembled the thick jungle that troops encountered during the Florida Seminole Wars. By 1868, a slow migration of settlers moving to the coast occurred, many residents moving from the interior where significant settlement had already occurred. Among the first settlers were the Hay, Fillman, Arnold, Lang, and Frierson families. These early families relocated from areas near Brooksville and Dade City where they had previously lived for a time. Leaving those populated areas, these families traveled until they reached the coast, arriving in an area that was void of inhabitants and had remained virtually untouched since the resident Native Americans had left. Lakes, tidal creeks, and area waters teemed with all types of fish while the swamps and woods were bursting with wildlife and dangerous vermin. The dry lands were covered with immense oaks, pines, and magnolias, while the wetlands were growing with cypress, orchids, and various other wild plants that had grown for hundreds of years. Bears, bobcats, rattlesnakes, alligators, wild pigs, quail, turkey, and herds of deer and other wildlife were common sights. The summer brought an almost epidemic-like quantity of disease-carrying mosquitoes and pesky fleas, as well as the hot, muggy summer days and nights. During the winter, settlers had relief from the bugs and heat; however, they faced a new myriad of troubles, which included frost and sometimes frozen conditions. The early Hudson frontier was a dangerous and trying place for these early families.

Many of these families settled an area considered north Hudson today, near the Sea Pines Subdivision, making their small settlement upon lands that they did not yet own, and until they acquired ownership, mostly from the state, they were considered squatters. These early residents built typical cracker-style homes with detached kitchens while planting simple crops for basic foods. Wood for their homes was rough cut, by hand, from the many tall pines. Other food was

gathered through their many hunting and fishing expeditions. By 1874, William Malachi Lang was the first to establish and engage in the fishing industry, using the Gulf waters to catch the delicious mullet and other fish that were abundant. John William Hudson once recalled, "The price of mullet then, and for several years after, was one cent each as they were thrown out on the bank." Lang was the first of many residents who relied on the Gulf waters as a career and industry of fishing and sponging. Shortly after Lang's fishing business had been established, the area became commonly known and referred to as Lang's Settlement. Among the first accomplishments of the small community was the construction of a schoolhouse where their children received a formal education. This early school was entirely community supported with residents providing property, building materials, labor, teachers' pay, and a minimum number of students; failure of support resulted in closure of the school. The earliest records, from October 1877, show that this early school was called "Lang's School" with "William Malachi Lang, William Graham Frierson, and Daniel J. Strange" acting as the first trustees. Believed to have been a typical one-room log structure, Benjamin Lee Blackburn was recorded as the first teacher. Early records also indicate that Blackburn received $58 for teaching a full term, which was 66 days long or three months, from July 5 to September 30. While there were separate grade levels, every child attended the same and only school. Typically one teacher was responsible for teaching the several grade levels of each child. Students received a simple education of reading, writing, and arithmetic.

Between 1878 and 1887, several new pioneer families arrived at the coast and with the growing community came changes and expansion. Like those before them, these new settlers mainly followed a migration from the interior of the county. Each of these families gave to the Hudson community in their own individual way. Among them was Hudson's namesake family, who arrived permanently in 1878, settling about 2 miles south of the original Lang's Settlement. According to Isaac Washington Hudson Jr., "For their new home they chose some high ground not far from an inlet of the Gulf and near a large spring." This spring came to be called Hudson Spring. After settling, Isaac Washington Hudson Sr. began selling produce, which was shipped to Cedar Key via a sloop. Isaac Jr. once said, "A man named Hall, from the Bayport settlement, ran some produce from the Hudson farm up to lively port of Cedar Key on his sloop. Isaac Sr. liked the sloop, traded Hall a couple of oxen for it, and his older son, Joseph Byrd, took over the freight run to Cedar Key, which was a deep water port and terminal of the nearest railroad. He marketed cured pork, sugar cane, sweet potatoes, and 30 gallon barrels of cane syrup. Tomatoes, a novelty at the time, which the Hudsons [sic] found grew well on their land, sometimes made up part of these cargoes, often sold as provisions for the ships anchored at Cedar Key." While it was a full load on the way, by no means was the sloop empty on return, as merchandise of all types was brought back. Making the business a family venture, John William and Joseph Byrd Hudson soon established the Hudson Mercantile Store. Hudson's first general store, it was built to be situated on the banks of the big spring with a deck extending out to accept incoming boats. Eventually Isaac Sr. and his sons established a fishing business. During the September-November season, they often sat up all night "butchering" mullet for their customers, who sometimes came from as far as Sumter and Polk Counties, or even from Orlando, driving through the woods on trails in their buggies or wagons. From the proceeds of their ventures, the Hudsons were able to purchase 200-plus acres of property from the state. On May 4, 1882, John William Hudson filed an application to establish the community's first post office, which was granted under the name Hudson. Around 1882, Isaac Sr. hired survey crews to plat the family's property into a town, which then carried the family name. While the community of Hudson was platted, the areas that were considered part of the community were much larger, including areas beyond that of the town plat, such as Lang's Settlement. This outlying area is known today as the Greater Hudson area. In 1886, the *Florida Gazetteer* showed Hudson's population had reached 16 families, mainly comprised of growers and farmers.

With new growth came new industry. While many residents were still farming, fishing, and sponging, the area's richness in turpentine and timber was soon discovered. The Greater Hudson area had several thriving turpentine camps, each with their own naval stores to sell the industry

products. Among the more notable turpentine camps of the area were the Tanner Brothers and Weeks Brothers camps, both situated along today's Denton Avenue. These camps typically created small independent communities of their own; however, these communities disappeared with the industry. Some may have heard of the Weeks Brothers camp as it became commonly known as Needmore, one of the long-forgotten turpentine communities of the Hudson area. Along with turpentine came sawmills as pine and cypress trees were milled and used for their very desirable building wood. The Greater Hudson area was also home to several thriving sawmills, which cut and cleared thousands of acres of timber. Among the area's biggest, most successful, and most well-known sawmills was the Fivay Sawmills, which aided greatly in the arrival of the railroad to Hudson. In 1903, Hudson resident and surveyor Henry Clay Bush was hired to conduct a survey for the construction of the new railroad line, which was to extend from Brooksville to Hudson. May 26, 1904, local newspapers reported the new Brooksville-Hudson Railroad spur had been opened. This new railroad extension was built for the purpose of moving early mill workers from Brooksville to Hudson and from Hudson continuing on to the mill by other modes of transportation. Eventually more tracks were laid, and the train could travel from Brooksville to Fivay to Tampa, with Hudson as a stop along the way. The railroads also offered easy transportation, not only for passengers but also for merchandise, and Hudson prospered in many ways, including the addition of a railroad depot, telegraph office, and several general stores.

The turn of the 20th century not only brought new industry, but there was a new generation of pioneers to settle, making Hudson their home—families such as Lysek, Hatcher, Pinder, Moseley, Gillett, and Carter, to name a few. Around 1890, the Hudson Mercantile Store was robbed and burned to the ground as the thieves likely made their getaway by boat. Just like a forest fire creates new growth, so did the devastating fire, which consumed Hudson's first general store. Shortly after the fire, Marquis Moseley built a new general store and Hudson's new generation of growth began. Then came the addition of Littell's Mercantile Store, owned by Corwin Pearl Littell and operated by William Hankinson Nelson, his father-in-law. By 1911, with a population of 150, the little Hudson community was thriving with three general stores, several fishing/sponging businesses, and two churches, as well as its post office and school. Most of these new businesses had been situated and centered at the spring where the former Hudson Mercantile Store was located, while the area sawmills and turpentine camps were mostly in the outlying Greater Hudson area. Eventually the resident fisherman and spongers built several warehouses along the creek, and a common sight was several boats anchored about the winding creek and in the spring. The railroad had made its way to the big Hudson Spring, making three stops along the way: the depot, the warehouses, and the wharf at the very end of the line where merchandise and barrels of fish or turpentine were transferred between the train and local boats. Hudson soon received the additions of several boardinghouses and a hotel built by Marquis L. Moseley. These simple wood-framed buildings left much to be desired but served their purpose for the community. After sitting dilapidated for several years, Moseley's hotel was revived in the mid-1920s, becoming Hudson's premiere fishing and hunting Gulf Springs Lodge, attracting guests to the spring. Guests could now arrive via railroad for a weekend trip of hunting and fishing at Hudson, and within walking distance of their rooms were three general stores, the Gulf waters, and as much hunting and fishing as could be desired. Among Hudson's more notable guests was Louisiana governor Huey P. Long, who enjoyed a stay at the lodge in 1929. The big Hudson Spring was not just the center of Hudson's commerce; it was also an early place of recreation for residents and guests alike. Some of the earliest photographs of the spring show people enjoying the sunshine as they fish and canoe. A few hundred yards south of the spring and down Hudson Creek was Cotton Island, where residents constructed bathhouses where they could boat for an afternoon picnic and swim in the beautiful spring-fed creek.

Today Hudson, Florida, has been placed on maps because of those courageous pioneers who worked toward a better community for everyone. Still today, nearly 140 years after the arrival of our first residents, Hudson continues to grow with the addition of new roads, subdivisions, schools, and churches. While many pioneer residents hate to see the growth of their small community,

in most cases, it is not the growth these pioneer residents hate but the destruction and loss of Hudson's historic past, which is not preserved. Each day, another piece of Hudson's history is lost to the bulldozers and in the name of progress. Only a few years ago, the historic Alfred Hudson home was demolished, without permits, to create a vacant lot, which still sits vacant today. Many of the buildings and homes that made the early Hudson community are gone, only to make way for a new subdivision or school. Today the site of the original Lang's Settlement is the Sea Pines Subdivision and former Sunwest Mines, with little of the past preserved. In more recent years, residents have witnessed a change in development with buildings being constructed with multiple floors. Area schools are no longer the small, community-supported, one-room schoolhouses; instead the school board is approving and building large industrial-type buildings that are sometimes two or three stories high and costing millions of dollars. As urban sprawl becomes an issue, developers start to build up instead of out with land becoming scarce. It is sometimes hard to imagine that even Cotton Island is gone, wiped off the maps during the development of Hudson Beach Estates upon the man-made lands. In exchange for Cotton Island, residents were given Hudson Beach, which is now closed for part of the year with high bacteria levels. Those early buildings that once surrounded Hudson Spring are no longer; in their place are modern mobile homes that have been situated to make Hudson Springs Mobile Home Park. In addition, Hudson Spring no longer flows because many area sinkholes were filled during development, causing underground flow to change. It is rather sad to say that the only way to see Hudson's historic past is through the camera lenses and photographs taken by Hudson's earliest pioneers.

One

HUDSON'S
NAMESAKE FAMILY

While the Hudsons weren't the area's first settlers, this family's dedication and hard work made the community known today. In 1868, leaving their farm in Andalusia, Alabama, the Hudson family headed south to Florida. Upon arriving in Pasco County in 1870, the Hudson family first settled in the small community of Chipco, north of Dade City, where Isaac Washington Hudson Sr. engaged in farming a 40-acre tract. After living in Chipco nearly eight years, Isaac Sr. became stricken with bronchial troubles, believed to have been caused by the many un-drained swamps and bay-heads around Chipco. As a result, Isaac sought a location that was closer to the Gulf, believing, like many, that the salt air would relieve his ailments.

In 1877, the family built a couple of small log houses near a big spring on the coast and frequently visited the area from their Chipco farm, according to Joseph Byrd Hudson. In February 1878, Isaac Sr. decided to permanently move the family to the coast, arriving to the new frontier in a two-horse wagon with the young boys driving the milk cows ahead of the team. They brought with them enough corn, bacon, sugar, and syrup to last until they could plant crops. The log houses built the year before sustained the family until a permanent home was built, one house being used for storage of supplies while the family of 11 lived in the other. By 1880, construction of the family's new home was completed and Isaac Sr. began selling produce from his crops, which brought good profits. From the proceeds, the Hudson family purchased 200-plus acres of property, including the location settled a few years prior. Soon the family established the community's first post office and general store. In 1884, the Hudson family had most of their 200 acres platted and surveyed into a town site, which carried their family name, Hudson. This new town was situated 2 miles south of the original Lang's Settlement.

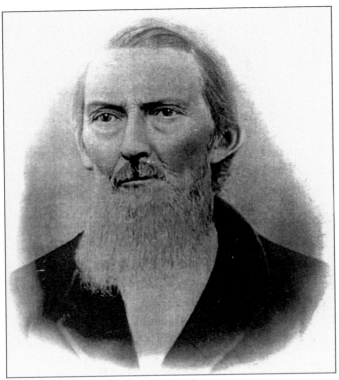

Isaac Washington Hudson Sr. was born May 17, 1825, in Monroe County, Georgia, to Byrd and Mary Bedingfield Hudson. On November 9, 1848, Isaac married Amanda Luverna Cobb and by 1860, along with their parents, moved to Andalusia, Alabama, where he engaged in farming. Becoming ill, in 1868, he loaded his family and possessions into a wagon and by caravan headed to Florida for healthier climates. After living in Madison County for about a year, the family moved to Pasco County by 1870, settling 40 acres in Chipco, just north of Dade City. After seven years and his bronchial sickness becoming worse, the family moved closer to the coast, settling what would be Hudson in 1878. The tintype photograph at right, from the 1850s, is believed to be an early image of Isaac Sr. around age 25. (Above, late Wyman Hudson collection; right, Camille Coors.)

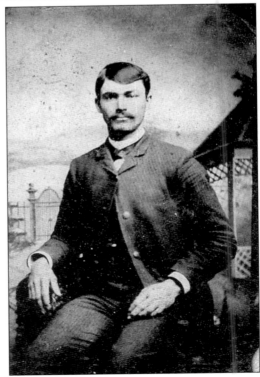

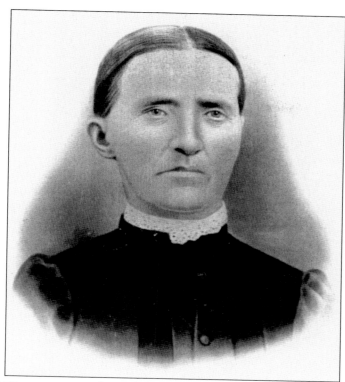

Amanda Luverna Cobb, born in 1831 in Georgia, was the second of at least eight children born to Joseph and Kiziah Wadsworth Cobb, pioneers of Georgia. Amanda Luverna's older sister, Nancy Elizabeth Cobb, married James Alexander Hudson, the older brother of Isaac Washington Hudson Sr. On November 9, 1848, Amanda married Isaac Sr. while living in Marion County, Georgia, where they had settled with their families. In 1850, Amanda and Isaac had the first of 12 children born to their union, Mary Ann Kiziah. The caring mother and wife that Amanda Luverna Hudson was, she not only cared for her husband during his sickness but also cared for their several children during their slow travels as they set out for Florida in 1868, seeking better climates. (Both, late Wyman Hudson collection.)

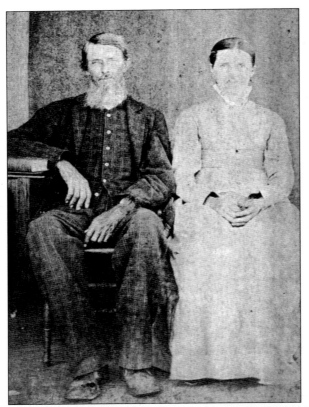

Children born to Isaac and Amanda Hudson were Mary Ann Kiziah (1849–1945), Thomas Byrd (born 1852), George (1854–1854), Joseph Byrd (1856–1950), John William (1859–1927), Ida Melissa (1861–1878), Franklin (1864–1919), Wiley Simon (1867–1940), Isaac Washington Jr. (1870–1972), Alfred Leander (1872–1968), Doxie (1875–1973), and James Thomas (born c. 1876). On August 3, 1878, six months after settling at the coast, the family suffered the loss of young Ida Melissa, who became the first interment in Hudson Cemetery. Most of the Hudson children remained close to home, aiding in the building of Hudson and Pasco County through farming, business, and politics. The family photograph below shows several Hudson children; those identified are Doxie holding the fan next to Wiley, while Alfred stands far right. The young man far left is believed to be young James Thomas; the other women are unidentified. (Left, late Wyman Hudson collection; below, Camille Coors.)

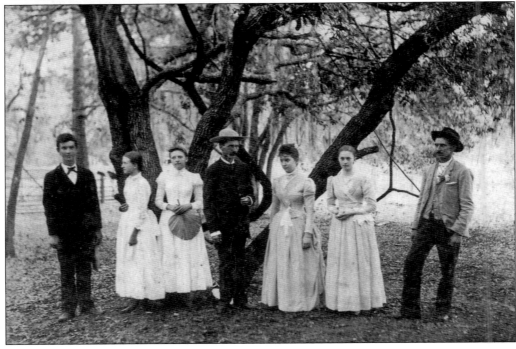

Construction of their first coastal home started in 1878 and was completed in 1880. During construction, they lived in a small cabin constructed a year or so prior. Another task was planting food crops, which eventually evolved into a family business of selling produce shipped to Cedar Key via the Hudsons' schooner. Profits allowed Isaac Sr. the means to purchase, from the state, enough property for a town, which became reality by 1884. Below, Isaac and Amanda are seated on the porch of their coastal home while seven-year-old Alfred feeds the chickens. The two standing are believed to be Joseph Byrd and John William. This home still stands at Pine Street and Harbor Drive as Hudson's oldest home. Pictured right is Mary Ann Kizah, first child of Isaac and Amanda Hudson, with her brother, Joseph Byrd Hudson. (Right, Gloria Surls; below, late Herschal Hudson collection.)

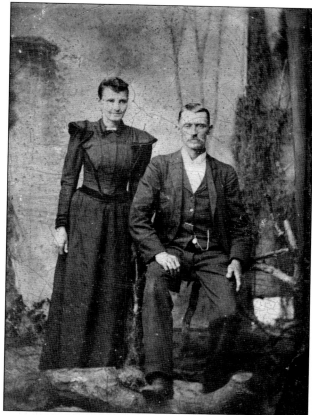

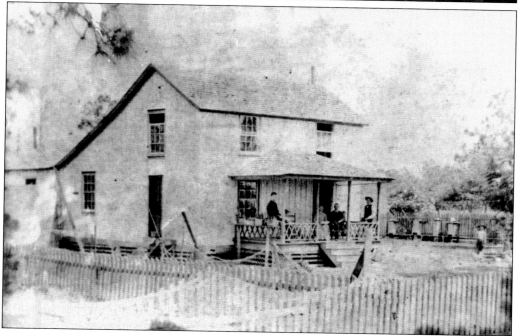

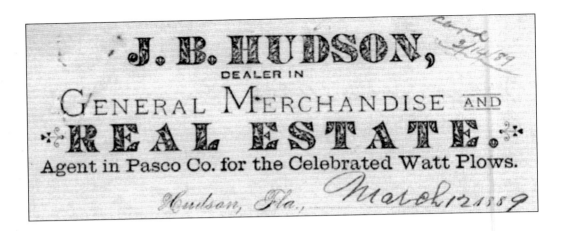

J. B. HUDSON,
DEALER IN
GENERAL MERCHANDISE AND
REAL ESTATE.
Agent in Pasco Co. for the Celebrated Watt Plows.

Hudson, Fla., March 12 1889

Joseph Byrd Hudson was born in 1856 in Marion County, Georgia. After arriving at the Florida coast in 1878, he established the community's first mercantile store. Situated on the banks of the big spring, decks extended out to accept incoming boats. Joseph Byrd was elected and served on the first Pasco Board of County Commissioners, 1887–1891, representing the residents in his district. Around 1890, the Hudson Mercantile Store was robbed and burned to the ground as the thieves made their getaway by water. While this was a great loss, the fire essentially made way for several new businesses. March 31, 1892, Joseph Byrd Hudson married Sallie Gillett, pictured here with their first child, Claude Willis. Their other children, all daughters, were Bernice Hudson (Thornton), Vida Hudson (Smith), and Alice Hudson (Bliss). (Letterhead from author's collection.)

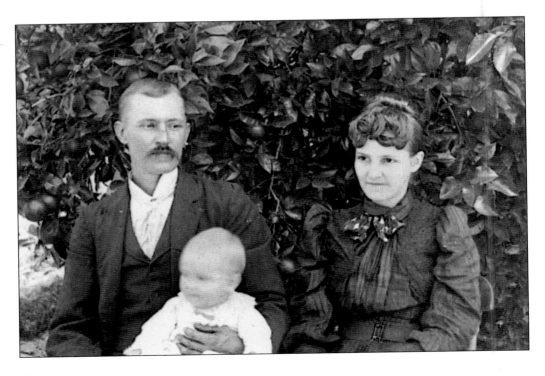

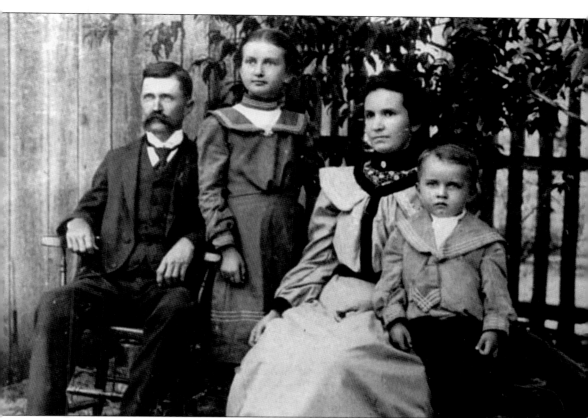

John William Hudson was born May 29, 1859, in Andalusia, Alabama. Operating the community's first boat, by 1881, John was making regular trips to Cedar Key, the only outlet for produce grown in this part of the country. On return voyages, he brought back merchandise, which was sold and traded to residents from their grand store. In 1882, he applied for and established the Hudson Post Office, serving as the first postmaster, and in 1883 served as a trustee of the Hudson School. July 3, 1890, John married Sarah Jane Fortner and by 1892 had moved to Fort Dade in eastern Pasco County. John and Sara had three children: Mabel, Mildred, and Dewey, the latter two pictured here with their parents. On June 19, 1921, John William Hudson was laid to rest at the Mount Zion Cemetery, dead of blood poisoning. More than 500 gathered to pay their final respects to this notable pioneer. (Elaine Stamas.)

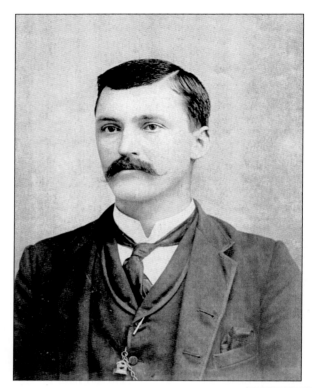

Franklin Hudson was born in September 1865 in Andalusia, Alabama. About 1883, Franklin piloted a boat owned by Port Richey founder Aaron Richey and by 1886 was working as an area carpenter. Around 1891, he left Hudson and settled in Paris, Texas, where he engaged in photography while being educated in osteopathy. In 1893, Dr. Franklin Hudson married Lucy Rivers Sullivan (below), who was born September 1876 in Mississippi, the second child of Knolt and Sallie Sullivan. Franklin became actively involved with the American Osteopathic Association, and around 1903, they moved to Edinburgh, Scotland, where he was representing doctor for the association. Franklin Hudson died in Edinburgh, Scotland, in 1918 during the great flu epidemic. (Left, late Wyman Hudson collection; below, Camille Coors.)

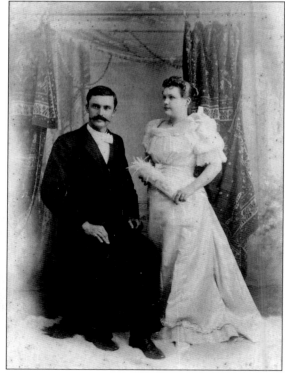

Wiley Simon Hudson was born June 17, 1867, in Andalusia, Alabama. Of all the Hudson boys, Wiley Simon seemed less interested in politics and business operations than his brothers. Instead Wiley followed in his father's footsteps and engaged in farming, applying what he had learned from working with his father. Throughout his life, Wiley remained close to his brothers, especially his younger brothers Alfred and Isaac Jr. Wiley soon built the home pictured below, along West Hudson Avenue, while farming the land. This later became the home of Michael and Ruby Carter Knowles, whose family still resides in the home. In 1908, Wiley Simon married Latona Hicks, and to this union were born Roy A. Hudson, Lula May Hudson, Irvin Hudson, Kathleen Hudson (Best), Jacqueline Hudson, and Julia Ann Hudson (Rewis). (Right, late Wyman Hudson collection.)

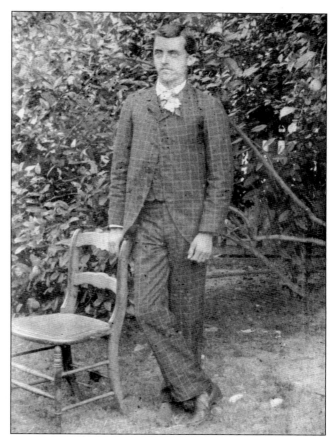

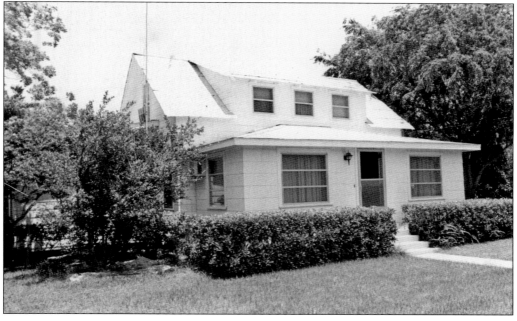

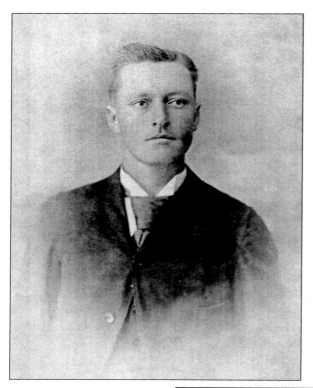

Isaac Jr., born November 1870 in Chipco, was the first Hudson child born in Florida. When the family moved to the coast, he remained in Chipco to attend school, living with the J. L. Porter family. In 1895, Isaac married Nettie Hay (below), daughter of Jesse and Jane Stevenson Hay, whom he had known since age 3. They moved to Elfers, where he opened a mercantile store partnered with Sen. Jesse Mitchell. In 1904, Isaac was elected as county commissioner and then served as sheriff in 1916 and 1924. December 28, 1917, at 1:10 p.m., Sheriff Hudson sprang the jail gallows at Dade City, hanging Edgar London in Pasco's second and final public hanging. Isaac Jr. died in 1972 at age 102, living his entire life in Pasco. (Left, late Wyman Hudson collection; below, Camille Coors.)

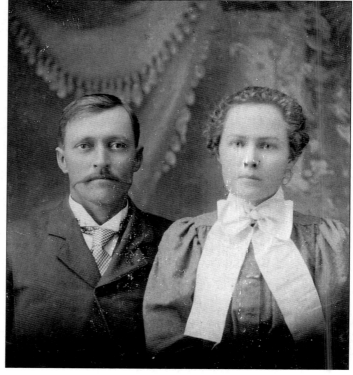

Alfred Leander Hudson was born August 22, 1872, in Chipco, Florida. After receiving an education, he engaged in carpentry work and by 1900 was living with his brother Isaac Jr. In December 1909, Alfred Leander Hudson married Annie Caroline Leopold, building the home pictured. By 1910, like Wiley, he engaged in farming his property, specializing in dairy that was trucked to local residents. He was also known for raising hogs and from time to time would bring fresh pork to residents, delivered from his horse-drawn wagon. When Isaac Jr. became sheriff, Alfred worked as the only constable or deputy to serve Hudson. Alfred and Annie Caroline Leopold Hudson had the following six children: Talmadge D. Hudson, Thelma Alberta Hudson (Moore), Deluxie "Luxie" Hudson, Hazel Blanche Hudson (Sigmon), Herschel Hudson, and Robert Vernon Hudson. (Both, late Wyman Hudson collection.)

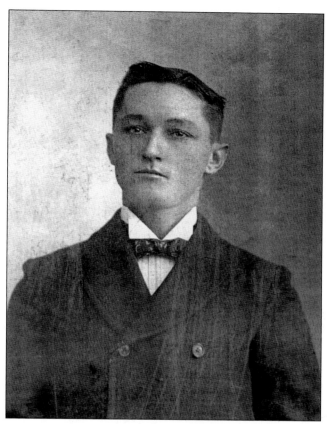

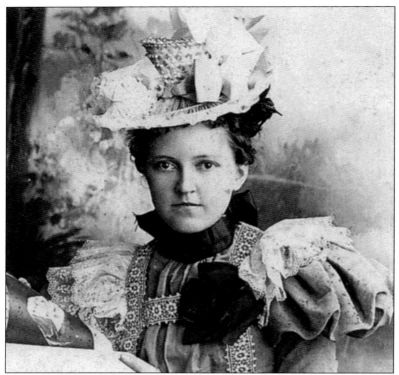

Doxie Hudson was born in December 1875 in Chipco, Florida. When younger, she was known for long, beautiful hair. By the early to mid-1890s, she became a Pasco County teacher, certified by the school board as a second-class teacher. Around 1898, Doxie Hudson married Judge A. Mobley and by 1900 had moved to Manatee County, where Judge engaged in farming their Palmetto property while planning for children. By 1910, Doxie and Judge had returned to Pasco County, settling in Dade City along River Road, now with young children. Doxie and Judge had three children: Florida R., Ralph H., and Frances. In January 1923, when Amanda Luverna Hudson passed away, she was living and being cared for by Judge and Doxie at their Dade City home along River Road. (Above, Camille Coors; right, late Wyman Hudson collection.)

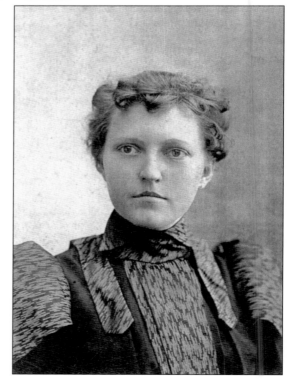

Two

Early Pioneers

When the Hudson family arrived at the coast in February 1878, there were few settlers who called this area their home; among them were the Lang, Hay, and Frierson families, who were instrumental in the development of the community's first school in the mid-1870s. As the Hudsons established the first mercantile store and post office, the community became more centered and defined, followed by more settlement. Between 1878 and 1885, several new pioneer families settled along the coast, families including but not limited to Bellemy, Rewis, Moseley, Brady, Stevenson, Littell, Bush, Howse, and Quertermous.

After building homes, these pioneers relied on farming and fishing as commerce formed around the Hudson Spring, attracting many new seafaring families. These new pioneer families included Knowles, Lysek, Hatcher, Pinder, Gillett, and Carter, to name a few. While there are many more families that could be included, these names are seen reoccurring throughout Hudson's history, and many of these families remain rooted here today. These families not only saw the changes of the 19th century, but many have witnessed the devastation of development in the 20th century. Much of Hudson's past has not been preserved; instead it has been demolished to pave way for the not-so-bright future and fast-paced life, which many of the Northern immigrants left behind when they decided to move to this small, tranquil town on the Gulf.

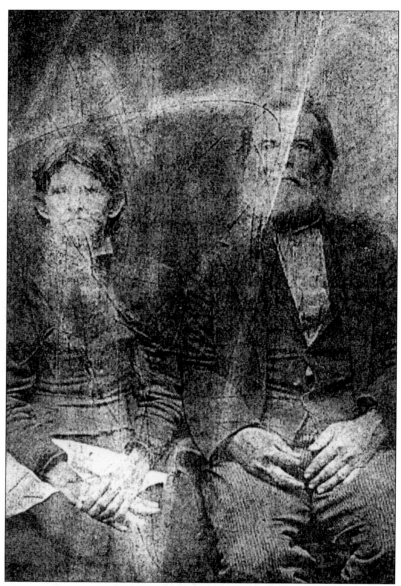

Among the first settlers were Charles "William" Malachi and Mary Jane Boyett Lang, pictured here. William, a Confederate veteran, was detached with the local home guard during the Civil War, working the coast while collecting beef cattle and scouting. Around 1872, the family, moving from Brooksville, settled Lang's Settlement, an area he likely scouted. By 1874, William had established the area's first fishing business, which was thriving by 1885. He was also instrumental in the development of the first school, then known as Lang's School, opened by October 1, 1875. Daniel J. Strange and William Graham Frierson served as the school's first trustees along with Lang, who served as trustee for more than 10 years. By 1900, the Langs had moved to Anclote and eventually to Dade City, where November 25, 1908, William died of typhus, typically caused by flea or tick bites. Today portions of Lang's Settlement lie beneath the Sea Pines Subdivision, while the 2,500-unit development SunWest Harbourtowne is being planned for the remainder. (Lang-Carey families.)

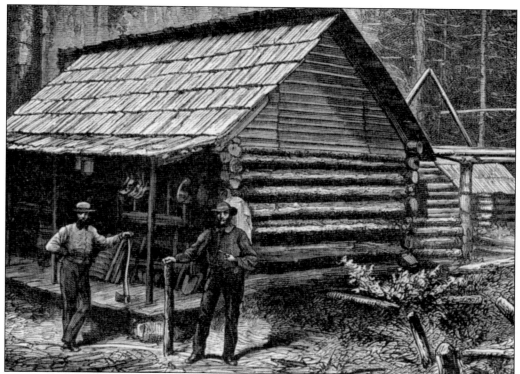

At the center of the proposed development is Fillman's Bayou, named for Martin D. Fillman, who settled the area about 1878. By 1878, Fillman was a trustee at the Lang School and on July 13, 1882, purchased 40 acres from the state. Following the Fillmans were the Arnolds, who settled southeast of the Fillmans. Upon settling, James Arnold began construction of the simple log cabin pictured here with him and Martin. While Martin was an avid sportsman, James found employment at the Weeki Wachee Sawmill until about 1887, when he and his wife took employment at a boardinghouse inland. The 1957 aerial below shows the once pristine area now destroyed by lime rock mining, including the Fillmans' farmstead west of Old Dixie. Portions of this area still remain undisturbed until future development begins. (Above, *Un Francis Dans La Floride*; below, author's collection.)

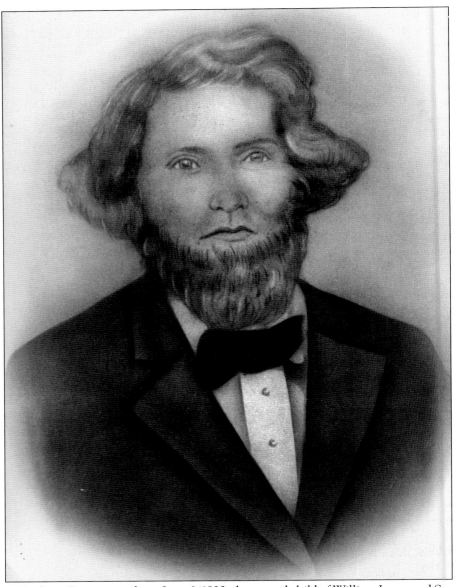

William Graham Frierson was born June 6, 1830, the second child of William James and Sussanah Keziah Graham Frierson. When William was 14, his father died, and he, with his brother John, took responsibility for the South Carolina plantation. Around 1854, William married Sussanah Goodman. At the outbreak of the Civil War, William enlisted at the Sumter District with the Confederacy and was mustered into service with Company K, 23rd South Carolina Volunteers, under Capt. Thomas Dickey Frierson, his uncle. On September 27, 1864, William was wounded and was admitted to the Episcopal Church Hospital in Williamsburg two days later. After returning to service, on March 25, 1865, he was shot in the left thigh by a Union minié ball while at Petersburg, where he was taken prisoner and sent to Camp Hamilton on May 6, 1865, and on to Newport News, Virginia, on May 9 where he was paroled at war's end. In December 1867, William collected his family and boarded a boat at Charleston headed for Florida, where he met his uncle Aaron Taylor in St. Augustine who took them to an area west of Brookville.

HOMESTEAD PROOF—TESTIMONY OF CLAIMANT.

William G. Frierson being called as a witness in his own behalf in support
of homestead entry, No. *16756*, for *N½ of NW¼ N½ of NE¼ Sec 19 Tp 24 Rg 17*
testifies as follows:

Ques. 1.—What is your name, age, and post office address?
Ans. *William G. Frierson, 63 yrs of, Mayflower Fla*

Ques. 2.—Are you a *native born* citizen of the United States, and if so, in what State or Territory were
you born?
Ans. *I am, South Carolina*

Ques. 3.—Are you the identical person who made homestead entry No. *16756* at the
Gainesville land office on the *4th* day of
May I am 1886, and what is the true description of the land now claimed by you?
Ans. *N½ of NW¼ N½ of NE¼ Sec 19 Tp ne Rg 17*

Ques. 4.—When was your house built on the land and when did you establish actual residence therein?
(Describe said house and other improvements which you have placed on the land, giving total value thereof.)
Ans. *I built in May 1886 and built a new house
In May 1886 2 pen house dining room and
Kitchen attached 30 x 17 feet 6 acres under fence and in cultivation*

Ques. 5.—Of whom does your family consist; and have you and your family resided continuously on
the land since first establishing residence thereon? (If unmarried, state the fact.)
Ans. *Wife and two Children, We have*

Ques. 6.—For what period or periods have you been absent from the homestead since making settle-
ment, and for what purpose; and if temporarily absent, did your family reside upon and cultivate the land
during such absence?
Ans. *I have not been absent over one week at any
one time, my family has always resided on
the land*

Ques. 7.—How much of the land have you cultivated each season and for how many seasons have you
raised crops thereon?
Ans. *5 + 6 acres Every season*

Ques. 8.—Is your present claim within the limits of an incorporated town or selected site of a city or
town, or used in any way for trade and business?
Ans. *It is not*

Ques. 9.—What is the character of the land? Is it timber, mountainous, prairie, grazing, or ordinary
agricultural land? State its kind and quality, and for what purpose it is most valuable.
Ans. *Common timber and farming land*

Ques. 10.—Are there any indications of coal, salines, or minerals of any kind on the land? (If so,
describe what they are, and state whether the land is more valuable for agricultural than for mineral
purposes.)
Ans. *Not that I know of*

Ques. 11.—Have you ever made any other homestead entry? (If so, describe the same.)
Ans. *I have not*

Ques. 12.—Have you sold, conveyed, or mortgaged any portion of the land; and if so, to whom and for
what purpose?
Ans. *I have not*

Ques. 13.—Have you any personal property of any kind elsewhere than on this claim? (If so, describe
the same, and state where the same is kept.)
Ans. *I have not*

William G Frierson

I HEREBY CERTIFY that the foregoing testimony was read to the claimant before being subscribed,
and was sworn to before me this *31st* day of *March* 18*9*

Around 1875, William moved his family from Brookville to the coast, settling near the Lang
family in north Hudson and at a location known today as Frierson Scrub near Grace Memorial
Gardens Cemetery. By 1877, William had taken a position as trustee of the Lang's School, where
his children were educated. William and Sussanah had 10 children, all of whom married into other
pioneer Hudson families. In May 1886, the Friersons moved about 1 mile southeast of Frierson
Scrub, where William built a log dwelling measuring 30 by 17 feet, according to his homestead
proof claim (above). This typical cracker-style home had a detached kitchen and dinning room.
Here William planted crops for making a homestead of 160 acres consisting of common timber
and farmland. Today the 160-acre Frierson homestead would be located along the south side of
Denton Avenue. William died August 5, 1898, and was interred in Vereen Cemetery beside his
wife, who preceded him by five years. (Claudia Rowe.)

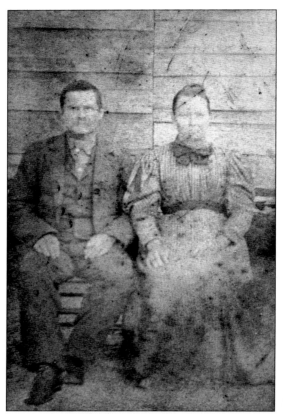

Another early family was the Hays. Jefferson "Jesse" Taylor Hay was born April 7, 1850, near Brooksville to pioneer residents Abraham and Sarah Hay. Around 1870, Jesse moved to an area east of Port Richey, purchasing the property from the State of Florida. While Jesse settled east of Port Richey, his older brother William Byrd Hay had decided to settle on the coast in north Hudson, near the present New York Avenue and Old Dixie Highway, where his parents settled with him. Shortly after arriving in Hudson, Abraham Hay passed away and was buried in a naturally marked grave on the family's property where the burial remains today. In 1872, Jesse married Jane T. Stevenson, daughter of Samuel and Elizabeth Osteen Stevenson. Sometime around 1886, Jesse and Jane, pictured here, settled in Hudson, perhaps to be closer to William.

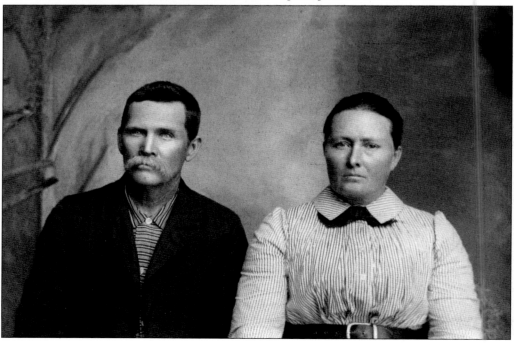

In Hudson, Jesse settled 160 acres, building a home in applying for homestead situated today on the east side of Hicks Road near Veteran's Memorial Park. While Jesse relied on farming, September 1887 school records show he served as a school trustee with neighbor William Frierson and brother-in-law Constantine "Bud" Stevenson. Jesse and Jane had five children, all born in Pasco County. Right, in 1900, are Jesse and Jane with three of their children; between them is Nellie and behind from left to right are Ida Myoma, Mary, and friend Julie Gillett. Below are sisters Mae (left) and Nellie Hay. Around 1920, after living in Hudson for nearly 40 years, Jesse and Jane moved to Elfers, where they lived the remainder of their lives, both being laid to rest in the East Elfers Cemetery. (Both, Maranell Fleming.)

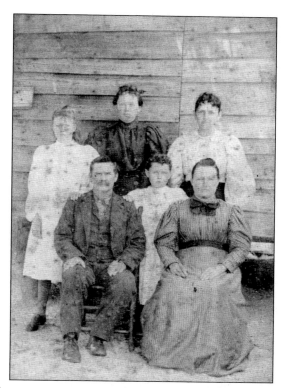

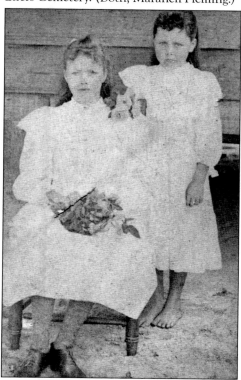

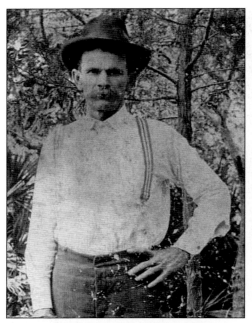

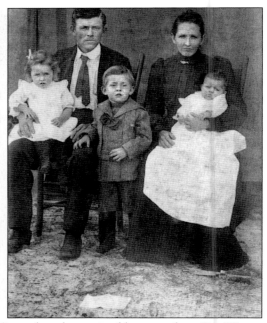

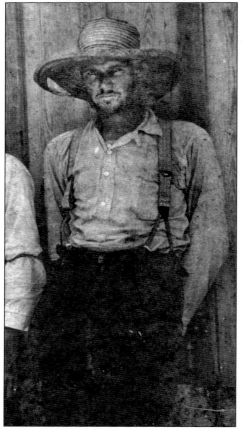

Several settlers arrived by water from Key West and the Bahamas, including John Alexander Brady II (above left), a sailor by trade who arrived in the mid-1870s. Upon arriving, he met area settlers and on January 29, 1878, married Amelia Adeline Frierson, daughter of William and Sussanah Frierson, in a ceremony conducted by Brooksville judge William B. Center. Eleven months after marriage, their first child, James William, was born at Frierson Scrub, perhaps the first male child born in Hudson. James engaged in the early sponging industry and by 1900 married Julia Ann Gillett, daughter of James and Rosa Andrews Gillett. Pictured above right are James and Julia with their first three children: Ivan Alexander, Mildred (on James's knee), and infant James. Pictured left is John Alexander Brady III, born around 1881, the second child of John II and Amelia Frierson Brady. (Above left, Harry Brady.)

Like those before him, John III followed in fishing and sponging the Gulf waters. By 1910, he had settled in Bayport with his wife, Addie M. (Pierce), and daughter Gladys. To the right is Margaret "Maggie" Susannah Brady, born December 9, 1884, in Hudson, the third child of John II and Amelia Frierson Brady. March 8, 1906, she married Charles Emanuel Hernandez, son of Antonio Maximo Hernandez and Catherine Virginia Lang Hernandez. Below is a young Thomas "Tom" E. Brady, born in 1886, the fourth child of John II and Amelia Frierson Brady. When old enough, Tom took to the Gulf waters to fish and sponge alongside his brothers. Those children of John II and Amelia Frierson Brady not pictured include Henry Brady, born in November 1888, and Adaline Brady, born in November 1889.

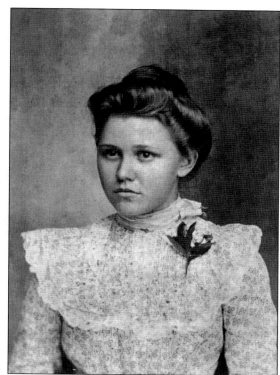

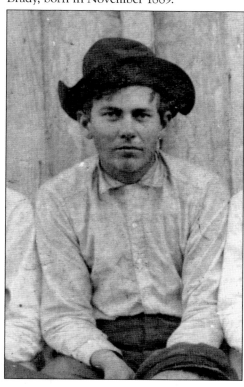

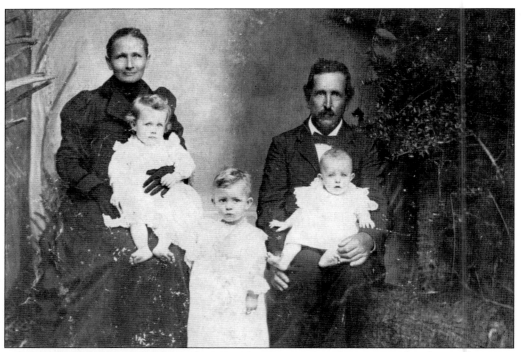

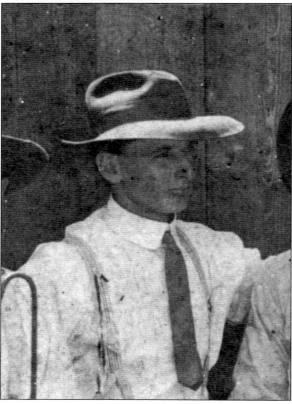

Another pioneer family was the Gilletts. James Franklin Gillett was born April 22, 1855, in Micanopy, the second child of George and Mary McNabb Gillett. In mid-1870, George moved his family to Pasco County, settling near Loyce. In August 1877, James married Rosa Ann Andrews, daughter of Franklin A. and Julia Ann Hay Andrews. James and Rosa had seven children: Sallie Gillett (Hudson), Julia Ann Gillett (Brady), George Wesley, Mary Lenora Gillett (Edwards), and James Franklin Jr. (left), who engaged in local farming; daughters Mattie Lee and Nettie Lee died young. James Sr. engaged in farming, and after the Great Freeze of 1894–1895, the family moved to Hudson, likely after their Loyce farm was devastated. Pictured above about 1885 are James and Rosa with children, from left to right, Julia Ann, George Wesley, and Mary Lenora. Both James and Rosa were laid to rest in the Hudson Cemetery, followed by several of their children. (Above, Ruth Conner.)

In later years, the Hay property in north Hudson was sold to Thomas and Julia Goethe Pinder, pictured right with son George Thomas Pinder. Thomas migrated to Florida from the Bahamas, first settling in Key West in 1864 and then Pasco County in the late 1870s, engaging in farming. Living near Anclote, he soon met and married Julia Goethe. Pictured below are Thomas and Julia Pinder with Sue Baillie at their sugar cane press and boiler in north Hudson. Sugar cane was commonly grown throughout the area, and residents processed the cane for its delicious syrup, a Southern specialty. Sugar cane is used in a wide variety of ways from sweetener for tea to being eaten on biscuits, bread, and rice. In 1919, Thomas Pinder served as a trustee for Hudson's first Church of God. (Both, Ruth Conner.)

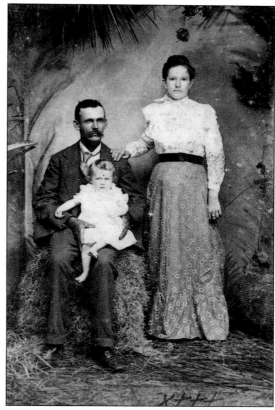

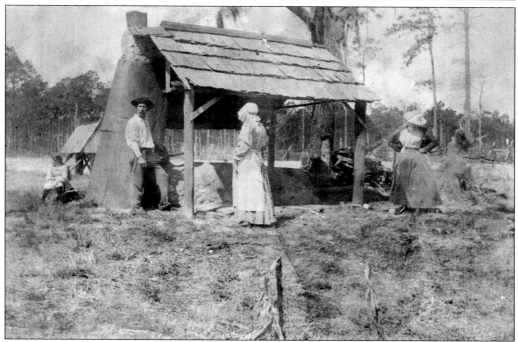

The Rewis family settled in Hudson around 1878 where Randall and Margaret Ann Jane Taylor Rewis homesteaded 160 acres near Hudson Avenue and Hays Road. Here Margaret and Randall established the Bee Tree Post Office and in 1885 erected the Bethlehem Baptist Church and School. Randall and his brother, Andrew, served as school trustees. Margaret and Randall had nine children, all born at the family homestead. In February 1889, Randall died and is believed to have been interred on the family's homestead, now the Word of Life Church facilities. After his death, Margaret remarried to Jesse Hiram Ryals, and they remained at the Rewis homestead, raising three more children. In 1903, Jesse and Margaret divorced, and while Margaret remained in the area, Jesse moved to Citrus County. Pictured here are most of Margaret and Randall's children, from left to right: (first row) Dan Rewis, Horrace Ryals, Aaron Ryals, and Elijah N. Rewis; (second row) Adolphus "Dolphus" Rewis, Ella Lee Rewis Weeks Slaughter, Charlie Rewis, Minnie Rewis McNatt, and Henry Rewis. (Author's collection.)

Jesse Hiram Ryals, pictured above, was born in 1864 in Hernando County to Ann Elizabeth Ryals and Confederate veteran Aaron Ryals, who during the Civil War partnered in the Confederate salt works located at Salt Springs, south of Hudson. August 8, 1889, Jesse married newly widowed Hudson resident Margaret Ann Jane Taylor Rewis in a small ceremony conducted in Brooksville by Rev. Absalom M. C. Russell with future Florida governor William Sherman Jennings as a witness. After marriage, Jesse became a trustee of the Bethlehem School, started by Margaret and Randall Rewis in 1885, and he changed the name of the school from Bethlehem to Bee Tree Pond. Margaret and Jesse had three children at the former Rewis homestead, Horace W., Aaron J., and Robert Maxey Ryals. In 1903, Margaret filed for divorce from Jesse, which was granted to her on February 2, 1903, by Judge Joseph B. Wall of Tampa. After the divorce, Jesse married Bell Scarborough from Inverness. Bell and Jesse had six children, who were born at their Inverness home. (Sandra DeLeo.)

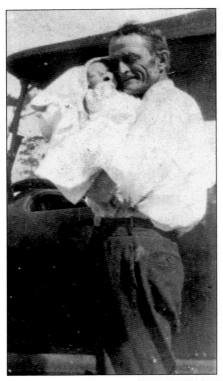

Born April 18, 1881, at the Rewis homestead, of the nine Rewis children Elijah "Lidge" Nathaniel remained in the area, and on August 6, 1906, married Maude Shearer (below), daughter of James M. and Jane Crum Shearer, pioneers of the Enterprise community near Dade City, after having lived near Brooksville. In 1910, Lidge oversaw prison crews leased to work area turpentine camps and in 1917 was elected as Hernando County commissioner, serving two terms until 1921. Returning to Hudson, the family lived in the former J. B. Hudson home and acquired the Arthur Carter property, near town, on a tax deed. Elijah and Maude, pictured below, had nine children, most of whom were born in Hudson: Iva Elma Jane Rewis (Stevenson), Randall James, Ella Lee Rewis (Goodman) (Sawyer), Roscoe Nathanial (married Julia Hudson), Walter Lidge, Helen Juanita Rewis (Hatcher), and Nita Maude Rewis (Keebler) (Donahue) (McCulty), pictured left with Elijah. (Both, Nita Maude Rewis McCulty.)

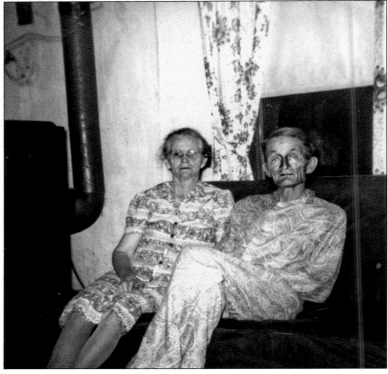

An important figure in Hudson was Henry Clay Bush, born January 13, 1857, near Durant, Mississippi, to John B. and Elvira F. Bush. In 1884, Henry homesteaded 160 acres north of today's Kitten Trail, south of Bolton Avenue. A justice of the peace, he provided notary services and performed marriages from his town office. May 30, 1886, Henry married Lula Isabelle Frierson, William Frierson's daughter, pictured below about 1887 holding daughter Maude Eva (Henderson) while they sit on the porch of their home, with daughter Annie Christie not yet born. Her brother John Taylor is believed to be in the wagon. In January 1887, Henry worked as teacher, serving one term at Hudson School. Afterward he surveyed railroads and an addition to the town filed for record February 1895. Henry died October 5, 1907, and was interred at Vereen Cemetery next to his wife, who preceded him 12 years earlier. (Below, courtesy Ann L. Knowles.)

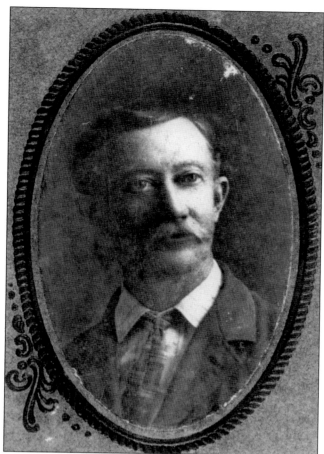

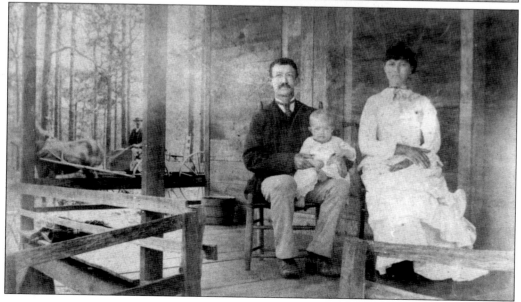

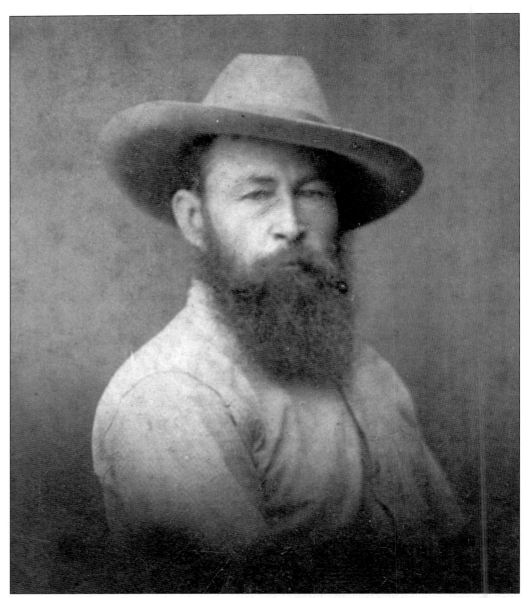

Vivian J. Lewis was born July 25, 1841, in Hardin County, Kentucky, the second child of 10 born to Dr. David and Lucy Lewis. On August 11, 1861, Vivian enlisted in the Confederacy and mustered into the 2nd Kentucky Cavalry, Company E, serving as 4th sergeant. After the war, he returned to Kentucky, starting his own farm until 1883, when he decided to move to Florida. Arriving in Hudson in July 1883, he settled 160 acres in north Hudson. By 1900, he purchased from the state 40 acres along Bear Creek, at the ford near Confederate veteran Hill W. Howse. Selling his 160 acres, these 40 acres became his new farmstead. Vivian was married only for a short time, having one daughter, Belle, who lived with him; little is known about his marriage. About 1900, Vivian opened a grocery store in town across the street from the post office at today's Pine Street and Hudson Avenue. Vivian died sometime between 1912 and 1920, put to rest in the Hudson Cemetery.

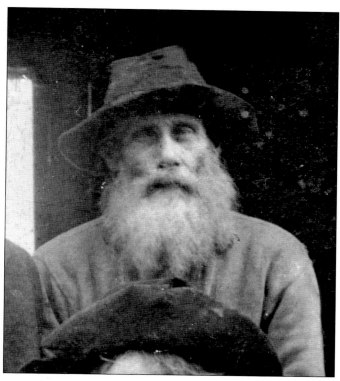

The first of the Knowles family arriving in Hudson was Michael Knowles Sr., a shipmaster by trade, born May 3, 1852, in Rocksound, Eleutheria, Bahamas, to a long line of seafaring men who settled the Bahamas in the 1640s and frequented the Gulf Coast during their sponging expeditions. In 1878, he settled in Key West, becoming a naturalized citizen, and from there continued working the Gulf waters. Reportedly on one expedition, he met William G. Frierson and other coastal settlers. On December 27, 1887, Michael Knowles Sr. married Jane Thincy Frierson (left), daughter of William and Susannah Frierson. Jane was born April 20, 1866, in South Carolina, the sixth of 10 children. She was about six years old when the family made the move from the Brookville area to the coast to settle.

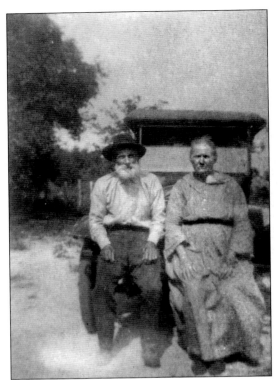

Being a hardworking and dedicated seaman, following their marriage, Michael continued working the Gulf waters while Jane lived for a time with her parents until he was able to return from the long sponging expeditions. The photograph here is the only known one of Michael Sr. and Jane Thincy Frierson Knowles together and in their older years.

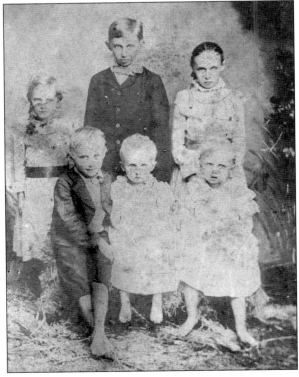

September 22, 1889, two years after their union in marriage, Michael and Jane had their first child, Robert Henry. Robert was the first of seven Knowles children born in Hudson. Pictured at right are five of the seven children born to Michael and Jane Knowles. They are, from left to right, (first row) Michael Knowles Jr., Leslie Lee Knowles, and Essie May Knowles (Hamilton); (second row) Belle Knowles (a cousin), Robert Henry Knowles, and Nancy Sussanah "Nannie" Knowles (Gillett).

In 1905, Woolsey Samuel and John "Jack" Henry Knowles arrived from the Bahamas, sons of Ann and Samuel Woolsey, a brother to Michael Sr. Both Woolsey and Jack engaged in sponging and fishing, and in 1906, Woolsey married Mary Eliza Brady, daughter of William and Mary Frierson Brady. Following their arrival, their parents and siblings William "Willie" and Sadie sailed from Nassau on October 31, 1908, aboard the schooner *Equator* destined for Hudson. Jack married Christie Bush, daughter of Henry and Lula Frierson Bush, while Willie married Ruth Holloway, related to Joseph and Florence Smith. Comprising the *Conch* crew, these true watermen knew every creek, channel, bayou, and rock pile from the Cootie River to Pine Island in Hernando. Above right are Woolsey and Jack, and below are Ruth and Willie Knowles on their 50th wedding anniversary in 1965. (Both, Ann L. Knowles.)

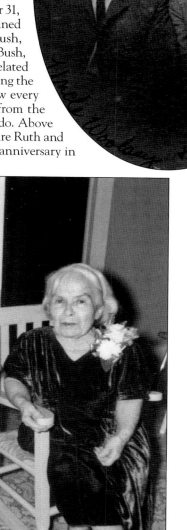

Another pioneer merchant was Marquis "Mac" L. Moseley, born August 1865 in Alabama to Confederate veteran Lewis Elijah and Cynthia Mariah Williams Moseley. On February 17, 1884, Lewis and the family settled in Hudson, homesteading 160 acres east of Hicks Road and south of Kitten Trail. In 1890, Marquis married for the first time to Genia ?, and shortly after, the entire family moved to town. Lewis settled along the north side of Hudson Avenue in the home pictured above while Marquis settled across the street. Marquis also acquired a large tract of property on the south bank of Hudson Spring and in the early 1890s built a general store and Hudson's first hotel, both overlooking the creek and spring. While Lewis was working as a local gardener, Marquis was busy building his merchant business and hotel interest while caring for his own family. Marquis and Genia Moseley both served as postmaster in 1892 and 1904 respectively.

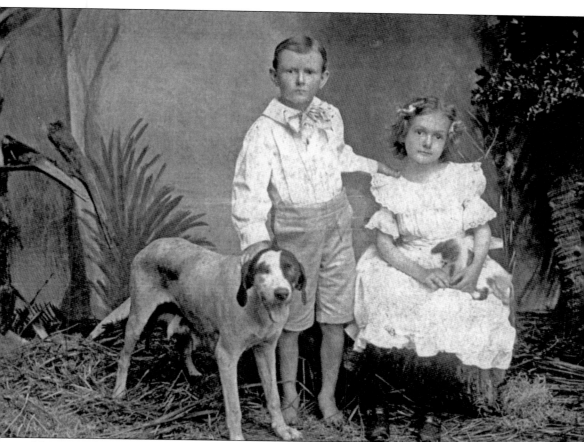

Marquis and Genia had five children who were all born in Hudson. Pictured here are their two oldest children, Marquis "Bruce" born November 1893, their only son, and Geneva, born April 1895; Evelin, Dots, and Maxine were their other three children. Both Bruce and Geneva received their early education and graduated from the Hudson school. Sometime around 1911, Marquis Moseley became employed with the Aripeka Saw Mills working as a real estate agent. As the mills closed their Fivay location, he was transferred to the Tampa office. It is believed that Lewis and Cynthia Moseley remained in Hudson and after their deaths may have been interred in the Hudson Cemetery in unmarked graves. In 1926, Marquis had much of his large property interest divided into lots, which became known as the Gulf Springs subdivision, situated around the spring and near his old hotel, then retained by new owners. Moseley advertised his lots through J. M. Mitcham, a local real estate agent and member of the Hudson Board of Trade.

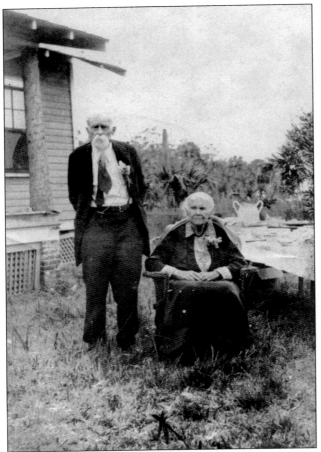

George Washington Coon Littell was born May 1, 1840, near Whitehall, Illinois, to Aaron and Jane Littell. On February 15, 1860, he married Amanda Robinson. After Civil War service with the 3rd Illinois Cavalry, they moved to Atchinson County, Missouri, until advised to move to healthier climates for their son Weaver, who died after arriving to Hudson in March 1886. They homesteaded northwest of the Rewises. About 1891, they moved to Aripeka, where George became postmaster of Argo Post Office on October 5, 1892, in addition to teaching at Argo School. October 24, 1898, he opened a new post office named Wheeler. With 13 children in 1930, George and Amanda were part of a Johns Hopkins longevity study. George died January 28, 1935, and was interred in Hudson Cemetery beside Amanda, who preceded him by three years. Below are George and Amanda with 5 of 13 children at their 70th wedding anniversary in Aripeka. (Both, Kay DeCubellis Waddell.)

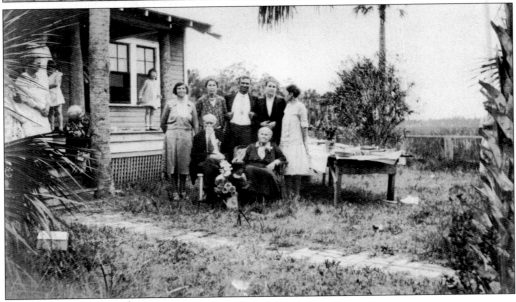

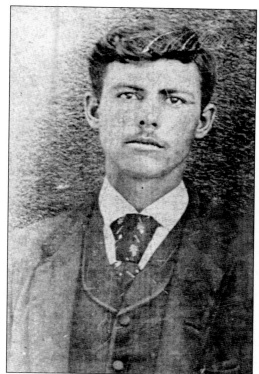

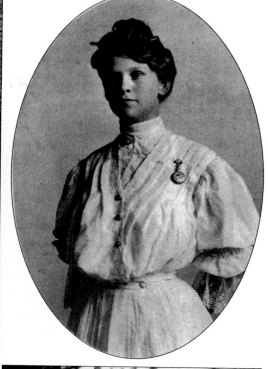

Born March 6, 1876, Corwin Pearl was the ninth child of George and Amanda Littell. In 1900, he was fishing while living with his brother Walter. On September 11, 1905, Corwin married young nurse Hilma Sue Nelson in a ceremony held in Gainesville at Dr. and Mrs. E. Lartigue's home. Returning to Hudson, they purchased Isaac Hudson Jr.'s former home on Pine Street, while Corwin opened Littell Sons Mercantile Store near Hudson Spring. Continuing to fish, he constructed a warehouse at the mouth of the creek and end of the railroad line. From 1909 to 1914, he served as Florida state representative and by 1920 had built a new home in north Hudson along Old Dixie Highway, where he engaged in farming. By 1930, he settled in Aripeka closer to his parents while working as a local bus driver. (Above left, late Mayhew E. Littell collection; above right and below right, Hilma Lysek Tracey.)

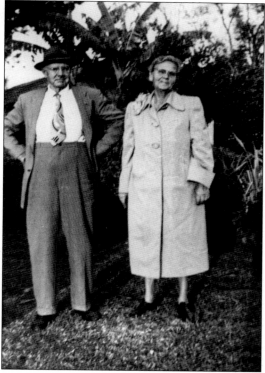

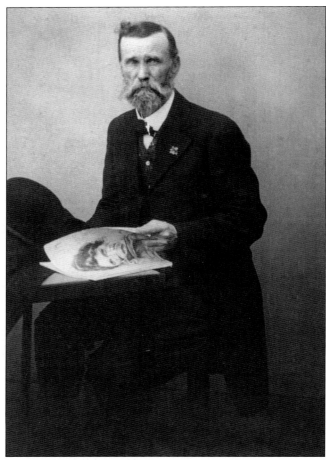

Hilma Sue Nelson Littell was the daughter of William Hankinson Nelson, born in South Carolina in September 1858. In 1884, William married and by 1900 had four children, Hilma Sue the oldest, followed by Louisa A., Laudis I., and William M. Living in Port Royal, South Carolina, the elder William worked as a grocer's clerk. Widowed about 1905, he moved to Hudson to be closer to Hilma Sue, who had already married. Here he took residence, with Pearl and Hilma remaining with them until his death in 1941. While Pearl was busy with his political campaign, William operated his mercantile store. Below is William with his daughter and grandchildren; pictured from left to right are Hilma Sue Lysek (Tracey), Beatrice Littell (Lysek), William holding Josephine Lysek (Nichols), Bartow Lysek, and Hilma Sue Nelson Littell. (Above, Hilma Lysek Tracey; below, Kay DeCubellis Waddell.)

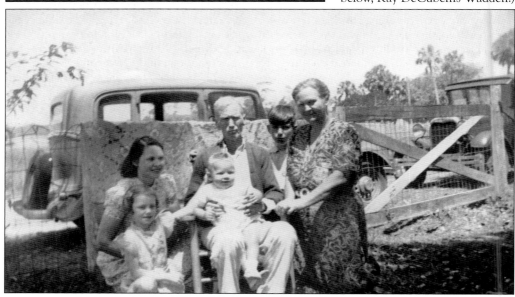

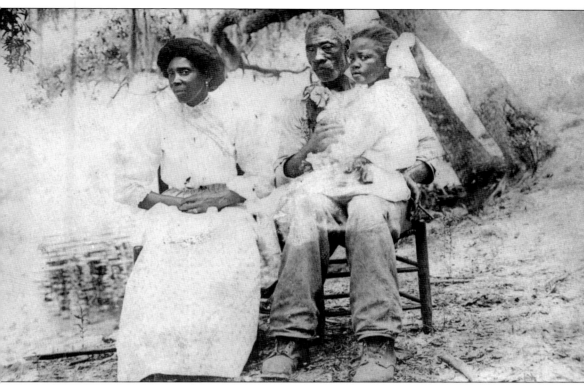

William Nelson brought "Uncle Harry" and "Aunt Clarissy" from South Carolina and employed them. Residing in Hudson for about four years, they were among the only African Americans. There were no African American schools, churches, or communities as in other areas of Pasco at the time. While the turpentine and sawmill industries mainly employed African Americans, they were typically here only as long as their employment. Harry and Clarissy differed since they were privately employed by Nelson, who reportedly provided them a place to live. Aunt Clarissy likely assisted with house duties while Uncle Harry made simple repairs and aided with farming. Sometime around 1909, they went back to South Carolina, desiring to return to their birthplace as their traditions did not permit burial elsewhere. It wasn't until 1925 when the "Booker T. Washington, an exclusive subdivision for colored people" was established in Port Richey, the first in west Pasco. Parts of this community still survive today along Pine Hill Road. (Kay DeCubellis Waddell.)

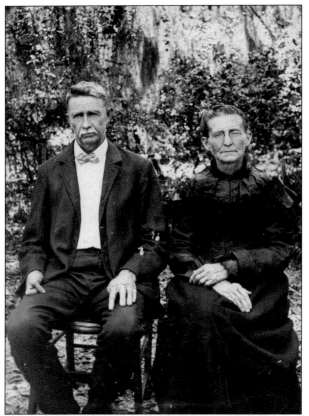

After the Great Freeze of 1894–1895, Henry Clay and Nettie Roach Carter settled in Pasco County from their Oxford homestead in Sumter County. Both were born in Florida two months apart, in May and July respectively, in 1850. Henry and Nettie married in 1871 and afterward settled in Lake Weir, Marion County, before homesteading 160 acres in Oxford a few miles south. There they farmed and planted their land with oranges. Pictured below are Henry and Nettie with daughter Ruby Helen (Knowles) between them and, from left to right, Ira J., Arthur C., Charles, and Eugene behind them. Young children Hattie and Emerson died in Oxford in 1884 and 1885 respectively. After losing their groves in the Great Freeze, the family moved closer to the coast, settling, for a time, in Loyce east of Hudson, where Henry found work.

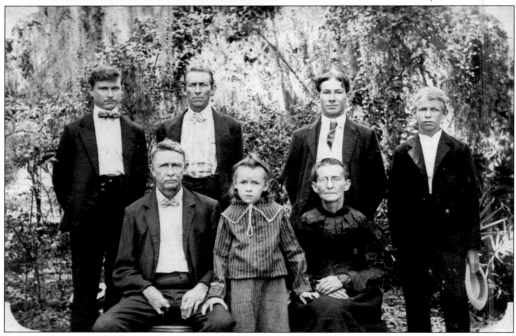

Around 1903, the Carters relocated to Hudson, building a typical cracker-style home with detached kitchen along Old Dixie Highway near the former Lang's Settlement and today's Sea Pines subdivision and golf course. They planted pecan and orange trees and sugar cane while the boys made their living as hunting and fishing guides, supplying the family with fresh meat. After Henry passed away November 23, 1919, and was interred in Oxford, Nettie remained in Hudson, where the boys cared for her and the farm. Nettie was tough and continued to work their farm, growing sugar cane and harvesting the pecans planted years before. Pictured at right is Nettie in front of her Hudson home with the family bible and wearing her favorite black silk dress. After her death on March 7, 1927, Charlie and Eugene continued to live on the family farm while still working as hunting and fishing guides. (Carter family collection.)

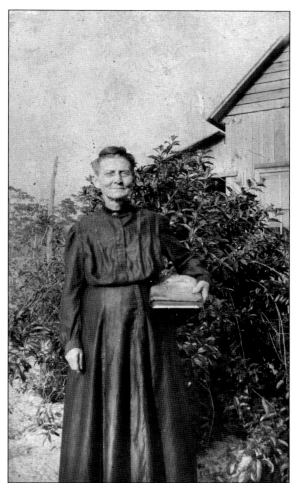

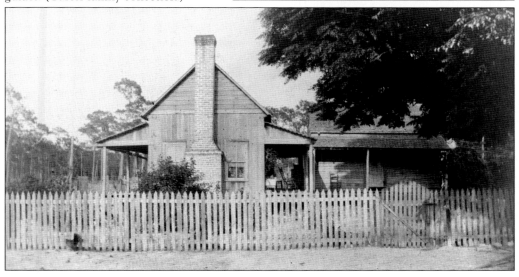

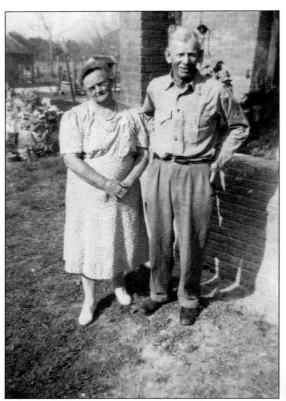

Hudson had a rather significant immigrant population, including French-Canadian, Italian, Polish, Chinese, and Bahamian nationalities. Among Hudson's Polish immigrants were Frank and Amelia Lysek, who settled in 1914 from Pennsylvania with the false promises of a Polish community being established at Fivay. They soon constructed a brick two-story farmhouse (pictured below), the bricks reportedly taken from the abandoned Fivay sawmills. Of Frank and Amelia's nine children, six were born in Hudson and raised on the family's farm, which was close to today's Hudson Avenue and Little Road near the Publix. Like most of the Polish families who settled in the area, the Lyseks were Catholics, which posed a problem since there were no Catholic churches in Hudson until it became a part of a Catholic circuit, with masses being held by Fr. Felix Ulrich from St. Leo. (Hilma Lysek Tracey.)

In 1919, Father Ulrich established Our Lady Queen of Peace in New Port Richey, and the Lyseks regularly attended services, having their children christened in the church. The Lysek children, pictured right, around their parents,—Natalie Ann "Tillie" Lysek (Brady), Joseph, Frank Jr., John R., Henry A., Thomas H., Emma Eva, and Marie—were all born in Hudson. On their farm, they raised corn, peanuts, sweet potatoes, watermelon, sugar cane, and sorghum while the boys engaged in fishing, sponging, and boatbuilding. Frank also sold peaches, which were common throughout the area. In the late 1940s to early 1950s, the family moved from their farm to the large home pictured below. This green-shingled, two-story house sat near Wild Cat Pond on U.S. 19 near the gas station now at Sea Ranch Road and U.S. 19. (Both, Hilma Lysek Tracey.)

John Gordon Hatcher was one of three Hatcher brothers to settle in Hudson. John Gordon was born in Levy County on July 20, 1885, to Isham Calvin and Lucinda Brown Hatcher, pioneers of Levy County. In 1909, John Gordon Hatcher married Lizzie Tillis, daughter of Preston and Lucretia Tillis, pioneers of Sumter County. Arriving in Hudson around 1921, like many, John soon found employment as a local fisherman to support his family. By 1923, they had earned enough money to purchase the Tom Brady home, where they settled to farm and raise chickens, pigs, and cows in the off-season. John also enjoyed hunting for rabbits, turtles, birds, and a good swamp cabbage. Eventually John started a successful commercial fish business to support his growing family. (Left, author's collection; below, Geraldine Hatcher Dougherty.)

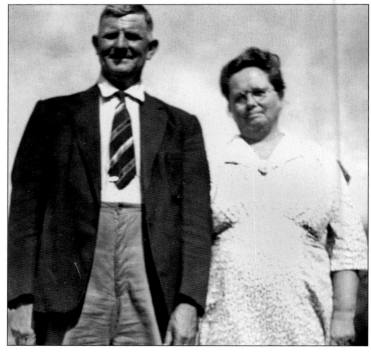

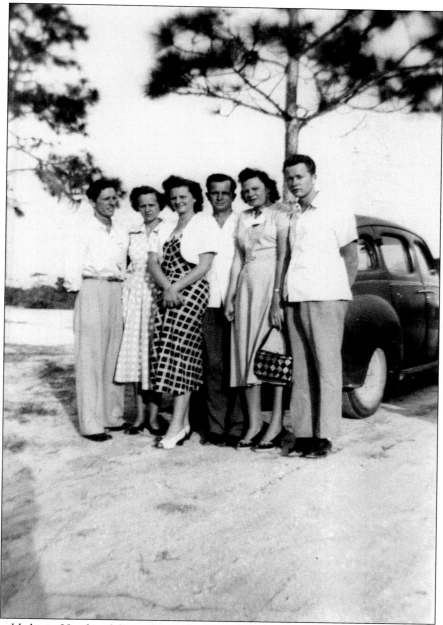

On a weekly basis, Hatcher delivered fresh mullet to customers as far as Dade City. He also became an active member in the Hudson Church of God, where he often preached. John Gordon Hatcher died on July 24, 1945, at Dr. Trelles Clinic in Tampa and was laid to rest in the Hudson Cemetery. Lizzie Tillis Hatcher later remarried C. M. Scott, but they had no children. Pictured above are John and Lizzie Hatcher's five children, from left to right: Albert, Eunice Hatcher (Heinkel) (Christy), Johnnye Hatcher (Sanchez) (Brown), Zeno Godfrey, Frieda Hatcher (Morales) (Pettinato), and Lonzie Edward. Of their five children, Frieda and Lonzie, the youngest two, were born in Hudson. As these children grew into adults, they all became active members the Hudson community, where they had been raised. (Geraldine Hatcher Dougherty.)

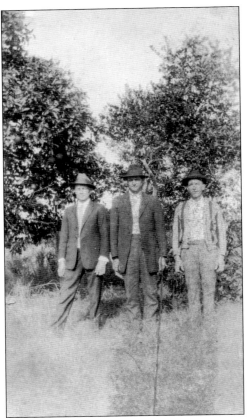

Salem Hatcher—born April 28, 1900, to Isham Calvin and Vilanta Morgan Hatcher, Isham's second marriage—settled from Levy County in 1922. Salem turned to fishing and during season never missed a high tide; off-season he worked building area roads, filling swampy areas along State Road 210, now 52, and later working on the Hudson-Aripeka Road, now Old Dixie Highway. Pictured left are the Hatcher brothers, from left to right, Salem, John Gordon, and James "Robert" about 1925. On May 15, 1929, Salem married to Eda Collum in Sumter County while following off-season work. Returning to Hudson, they raised their children, most pictured below from left to right: (first row) Andy, Udell, and Calvin; (second row) Alford, Nan, Eleanor, and neighborhood friend Nancy Green; (third row) Eda and Salem; daughter Vada is not pictured. (Left, Geraldine Hatcher Dougherty; below, the Hatcher family.)

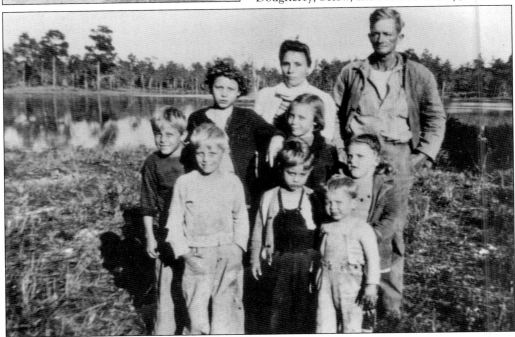

Three

THE HUDSON POST OFFICE

In 1882, John William Hudson filed an application for Hudson's first post office. The applicant was to select a short name, which when written would not resemble the name of any other post office in the United States. The name Gulf View was suggested by young Isaac Jr.; however, Isaac Sr. and John William Hudson decided on the name Hudson's Landing. On May 4, 1882, the application was sent to the Postmaster General's Office, and May 16, 1882, the new post office was approved. However, "Hudson's Landing" was denied and changed to the simple name "Hudson." The new post office was to be constructed by contractor Edward Muldro [*sic*] on land owned by John William Hudson.

John William served as Hudson's postmaster for more than 10 years. Between May 1882 and August 1953, there were 12 postmasters and three known locations for the historic post office. Those postmasters and their dates of appointment were Marquis L. Moseley (October 12, 1892), Thomas D. Duren (August 5, 1902), Homer C. Henderson (April 12, 1903), Genia Moseley (March 21, 1904), George N. Goshorn (April 19, 1906), Rev. Joseph H. Smith (June 27, 1906), Alice Gregg Davis (March 12, 1921), Ruby Helen Carter Knowles (May 14, 1922), Tessie J. Payne (October 14, 1925), Mary Frank (August 6, 1929), Della M. Gay (November 26, 1930), and Rev. John A. Wales (August 4, 1938). In 1940–1941, there was a clamor among residents to have the name of their post office changed to Gulf Springs, feeling it better represented the area's natural resources. This became a politically sensitive issue, and a circulated petition resulted in four signatures. On August 24, 1953, the Hudson Post Office was discontinued with services from New Port Richey effective on August 31, 1953; however, on December 1, 1957, the office was re-established, becoming a rural station of New Port Richey followed by a change to Port Richey on May 16, 1959.

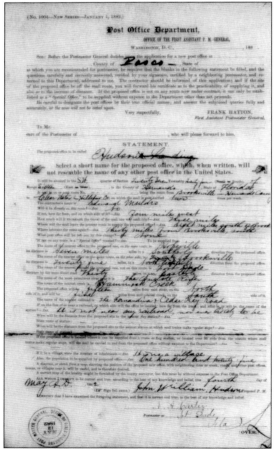

The application for Hudson's first post office, shown here, was signed on May 4, 1882, by proposed postmaster John William Hudson. The postmaster general received the application eight days later, and on May 16, 1882, the new post office was approved. Notice the application was filed under the name "Hudson's Landing." This name was changed to Hudson. This change was likely made by the postmaster general perhaps after finding the name Hudson's Landing was already taken. The new post office was to service 125 residents; however, its proposed location was not within a village or town. Ultimately it was the new post office that aided in the establishment and naming of the village or town of Hudson. (Both, author's collection.)

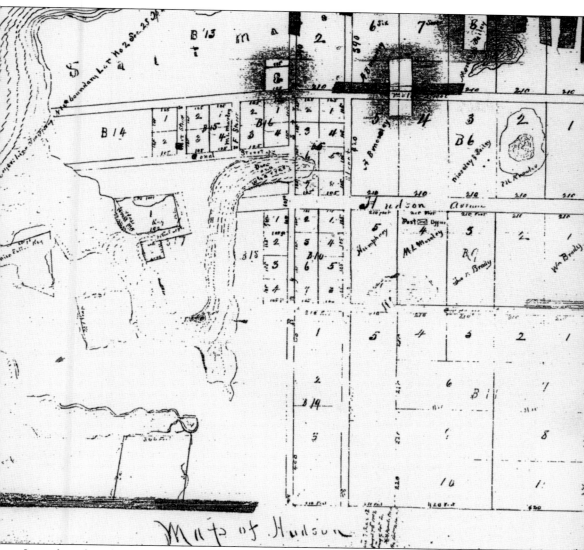

It is often thought a town was established before the post office; however, Hudson's post office was established before the town. In 1893, Henry Clay Bush surveyed and platted an addition to the town of Hudson and in doing so noted the second location of the post office as indicated on a portion of his plat map above, filed for record February 4, 1895. Notice that the post office was located on property owned by Marquis Moseley. It is believed the post office was kept at Moseley's home and moved to this location along West Hudson Avenue when he became postmaster October 12, 1892. It likely remained at this location until 1906, when George Goshorn became postmaster and is believed to have moved the office to his drugstore. Prior to the Hudson Post Office, residents had to travel to the Hopeville Post Office, a distance of about 7 miles south. (Author's collection.)

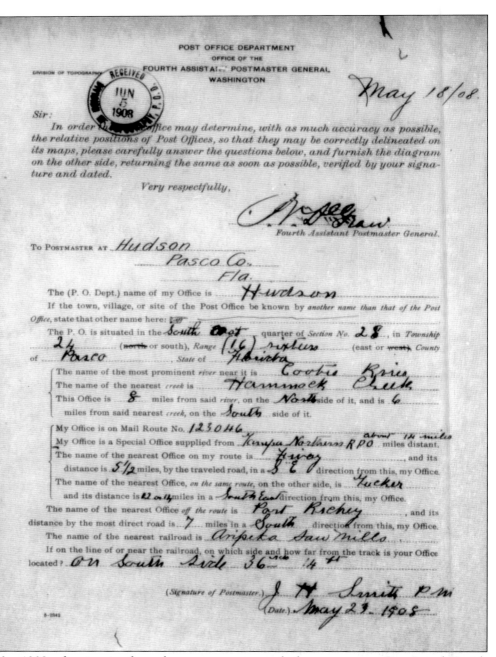

POST OFFICE DEPARTMENT

OFFICE OF THE

FOURTH ASSISTANT POSTMASTER GENERAL,

WASHINGTON

DIVISION OF TOPOGRAPHY

May 18/08

Sir:

In order *that this office may determine, with as much accuracy as possible, the relative positions of Post Offices, so that they may be correctly delineated on its maps, please carefully answer the questions below, and furnish the diagram on the other side, returning the same as soon as possible, verified by your signature and dated.*

Very respectfully,

Fourth Assistant Postmaster General.

To Postmaster at *Hudson*

Pasco Co.

Fla.

The (P. O. Dept.) name of my Office is *Hudson*

If the town, village, or site of the Post Office be known by *another name than that of the Post Office*, state that other name here: *no*

The P. O. is situated in the *South east* quarter of Section No. *28*, in Township *2½* (north or south), Range *(16) sixteen* (east or west), County of *Pasco*, State of *Florida*.

The name of the most prominent *river* near it is *Cooties River*
The name of the nearest *creek* is *Hammock Creek*
This Office is *8* miles from said *river*, on the *North* side of it, and is *6* miles from said nearest *creek*, on the *South* side of it.

My Office is on Mail Route No. *123046*
My Office is a Special Office supplied from *Tampa Northern RPO* *about 14 miles* miles distant.
The name of the nearest Office on my route is *Fivay*, and its distance is *5½* miles, by the traveled road, in a *S E* direction from this, my Office.
The name of the nearest Office, *on the same route*, on the other side, is *Tucker* and its distance is *12 or 14* miles in a *South East* direction from this, my Office.
The name of the nearest Office *off the route* is *Port Richey*, and its distance by the most direct road is *7* miles in a *South* direction from this, my Office.
The name of the nearest railroad is *Aripeka Saw Mills*.
If on the line of or near the railroad, on which side and how far from the track is your Office located? *On South Side 36 inch 14 ft*

(Signature of Postmaster.) *J H Smith P M*

(Date.) *May 23. 1908*

8-2549

In May 1908, after inquiry from the postmaster general, then postmaster Rev. Joseph Smith recorded the information (above), revealing the location of Hudson's newly constructed office closer to Hudson Spring and railroad depot built about 1903. (Brenda and Ann L. Knowles.)

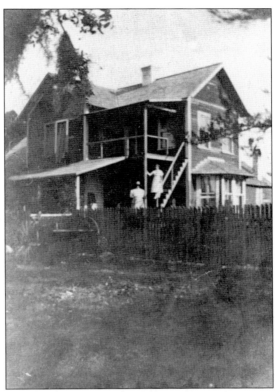

The simple frame building was reportedly built by Joseph Smith. Notice the sign on the building below, which reads "Post Office Hudson, FLA." Prior to construction of this permanent building, it is believed that the post office was moved about town with each postmaster. Today this small building would have been situated on the southwest corner of Hudson Avenue and Pine Street, next to the two-story home and boardinghouse of Joseph and Florence Holloway Smith (shown right). Later the home became the Glass House, which was destroyed by fire in April 1965. (Right, author's collection; below, Ann L. Knowles.)

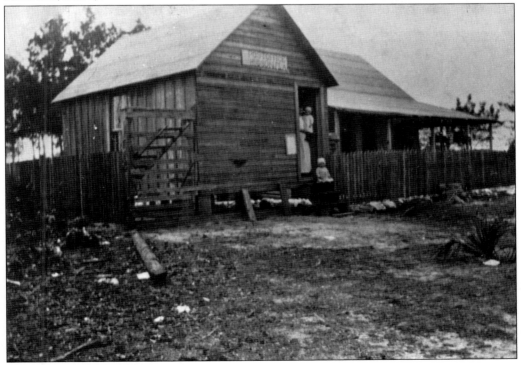

On May 14, 1922, Ruby Carter Knowles (pictured left) became interim postmistress after Alice Gregg Davis resigned. July 5, 1922, Ruby was officially appointed postmistress, and on August 1, Postmaster General Hubert Work signed and sealed her certificate of appointment (below). The following year, October 24, 1923, Ruby filed the appropriate forms (right) to have the post office moved to a new location. After approval, the office was moved 390 yards east of its 1908 location, to the southwest corner of today's Old Dixie Highway and Hudson Avenue. However, in 1923, when this location was decided, this section of Old Dixie Highway was State Highway 15 or U.S. 19.

HUBERT WORK

POSTMASTER GENERAL OF THE UNITED STATES OF AMERICA

TO ALL TO WHOM THESE PRESENTS SHALL COME, GREETING:

Know ye, That, reposing special trust and confidence in the intelligence, diligence and discretion of Mrs. Ruby Knowles *, I have appointed and do commission* her *Postmaster at* Hudson *, in the County of* Pasco *, State of* Florida *, and do authorize and empower* her *to execute and fulfill the duties of that office according to the laws of the United States and the regulations of the Post Office Department, and to have and to hold the said office with all the rights and emoluments thereunto legally appertaining, during the pleasure of the Postmaster General of the United States.*

IN TESTIMONY WHEREOF I have hereunto set my hand, and caused the seal of the Post Office Department to be affixed, at the city of Washington, this first *day of* AUGUST *, in the year of our Lord one thousand nine hundred and* twenty-two *, and of the Independence of the United States of America the one hundred and* forty-seventh.

By direction of the Postmaster General:

John H. Bartlett
First Assistant Postmaster General.

Hubert Work
Postmaster General.

IN REPLYING
MENTION INITIALS AND DATE

Post Office Department
FIRST ASSISTANT POSTMASTER GENERAL
Washington

AF-Ed

October 20, 1923

Postmaster,

Hudson, Florida.

POST OFFICE DEPT.
Division of

NOV 5 1923

TOPOGRAPHY

SIR:

With reference to the proposed change in site of the post office named below, and in order that the office if changed to the proposed location may be accurately represented upon the post-route maps, it is requested that you carefully answer the questions below and furnish a sketch according to instructions on opposite side of paper, which should be returned to the First Assistant Postmaster General, Division of Postmasters' Appointments, as soon as possible.

Respectfully,

FIRST ASSISTANT POSTMASTER GENERAL.

Hudson (Post Office.) Pasco (County.) Florida (State.)

If the town, village, or site of the post office be known by another name than that of the post office, state that other name here

The post office, if changed to the proposed site, would be 390 yds distance, East (N., S., E., or W.) from its present location.

The post office would be situated in the SW ¼ of section No. 28, in Township 24 (N. or S.) Range 16 (E. or W.), of the principal meridian, County of Pasco, State of Florida.

The name of the nearest river is , and the post-office building would be at a distance of on the (N., S., E., or W.) side of it.

The name of the nearest creek is , and the post-office building would be at a distance of on the (N., S., E., or W.) side of it.

The name of the nearest office on the same route as this post office is Aripeka Fla. and its distance is 5½ miles, by the traveled road, in a north (N., S., E., or W.) direction from the proposed site of this office.

The name of the nearest office on the same route, on the other side, is Port Richey Fla. and its distance is 9 miles, in a South direction from the proposed site of this office.

The name of the nearest office not on the same route as this post office is Greenfield (formerly Tucker) and its distance is 18 miles, by the traveled road, in a East (N., S., E., or W.) direction from the proposed site of this office.

The post office building would be on the (N., S., E., or W.) side of the Railroad, and at a distance of from the track. The railroad station name is

The post office would be , air-line distance, (N., S., E., or W.) from the nearest point of my county boundary.

Signature of Postmaster Ruby Knowles

Date Oct 24, 1923

1021

Here the post office was at the intersection of the two busiest roads through town, and it remained at this location for the next 30 years. (Author's collection.)

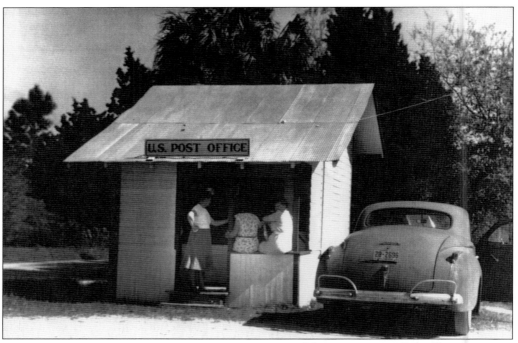

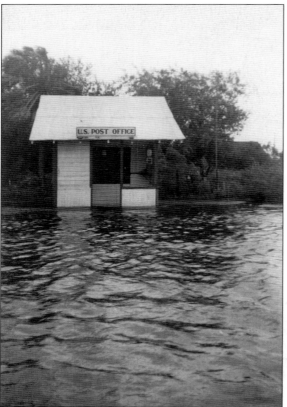

After postmistress Ruby Knowles received approval from the postmaster general in November 1923, she directed the move of the post office to its new location, and the simple frame building, with tinned roof, was constructed as shown here. In 1923, residents were proud of their newest post office situated at the southwest corner of the Dixie Highway and Hudson Avenue, then considered Main Street. While small, it served the postal needs of the community and their postmistress. (Above, Gloria Surls.)

During the war years, this was a place for residents to gather, awaiting letters from overseas. According to resident Eunice Hatcher Heinkel, "You just hadn't been anywhere if you hadn't made a trip to the post office each day. Everyone gathered at the little post office at 11 a.m. to wait for the mail." The small building stood at this location for 30 years with the personalities of five different postmasters, such as Della Gay (below). Through flooding waters in 1944, the small building stood the test of time; how many times the building was flooded is unknown. (Below, Ann L. Knowles.)

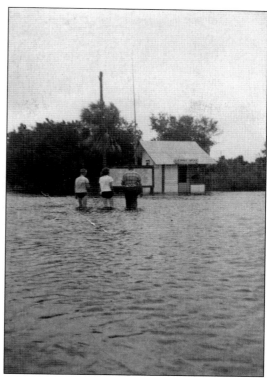

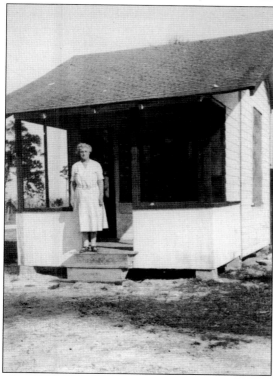

June 9, 1938

Hon. J. Hardin Peterson
House of Representatives
Washington, D. C.

Dear Friend Peterson:

Several citizens of Hudson, asked me to recommend to you Rev. John A. Wales, of Hudson Florida, for the position of Postmaster of said town which position will be open by virtue of the resignation of Postmistress, Mrs. Gay, to take effect on the 1st of July of 1938.

I know Rev. Wales, a retired Methodist Minister, and is now living in Hudson for his health. He informed me that he was Minister for many years in several large churches in the North and also Miami Florida, and is now minister of the Methodist Church in Hudson. Rev. Wales is an exceptionally well educated man who has traveled extensively and is well posted. He is very patient and kind and I believe will make an excellent Postmaster for Hudson or any other city of much larger population. He showed me an Honor Certificate issued to him by the Chairman of the Four Minute Men Committee of Public Information for honorable services that Rev. Wales rendered during the World War, the years 1917 and 1918, at his then home town Calera, Alabama. He also has certificates to the other aforesaid qualifications.

I was informed that someone else has already filed with you an application for said position, signed by a few citizens of Hudson, most of which are relatives, some informing Rev. Wales and myself, that they would not have indorsed the other applicant if they had known at said time that Rev. Wales would accept the position if it were offered to him. Rev. Wales also informs me that as soon as he learned of the vacancy that he applied through you for the said position and would have done so sooner, had he been informed of said vacancy.

I understood that said appointment is made upon your recommendation, for said reason I do hereby again highly recommend Rev. John A. Wales to you for the aforesaid position.

With kindest wishes and personal regard,
I remain,

Sincerely yours,

In 1938, residents learned Della Gay was resigning and began making their own recommendations for postmaster. On June 9, 1938, attorney Richard Morales, son-in-law of Albert and Fannie Roberts Hatcher, drafted the letter here, recommending Methodist preacher John Arthur Wales (right). (Late Albert Hatcher collection.)

John Wales, born in Pensacola on October 15, 1880, was the second child of Swedish immigrant and merchant Charles Wales. In 1903, after graduating college, John married and by 1910 had migrated to Decatur City, Alabama, following his call of God and working for the Salvation Army. By 1920, he took charge of a church in Dania City, Florida, until coming to Hudson when assigned to Hudson Methodist Church in the 1930s. Pictured below at Hudson Spring are, from left to right, Kenneth Knowles, postmaster John Wales, his wife, Florence Edna, former postmistress Ruby Carter Knowles, and (kneeling) Halla Mae Lorton Knowles, Kenneth's wife.

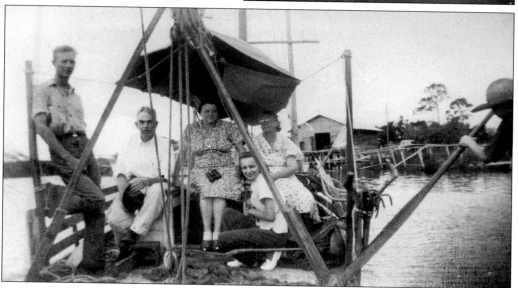

Tampa, Florida
January 16, 1941

Postmaster General
Washington, D. C.

Dear Sir:

As attorney for a group of property owners and citizens
of the town of Hudson, Pasco County, Florida, I am writing
you to formally request that the said name of Hudson be
changed to Gulf Springs, Florida, not because of any per-
sonal dislike for the name of Hudson or for a few individuals
named Hudson now residing in said town of Hudson, as most of
them are good and worthy citizens and highly respected by
their fellow townsmen; but because of a fact that the town
of Hudson is endowed by nature with many deep and clear springs
and in plain view of the Gulf of Mexico, less than ½ mile
from same and therefore, the said proposed name would be
significant of its God-given gifts and together with its fine
climate and its great abundance of fish and sponges a short
distance from the said town of Hudson, makes a very desirable
place to live in. While on the other hand, the name of
Hudson carries no such significance, but is only just another
name. For said reason, as attorney and spokesman for the
said citizens wishing to change, I will appreciate it if
you will let me know what petition or other requests are
required before said requests can be considered. I will as
attorney for the Hudson Improvement Association call a
meeting of the citizens of Hudson, if you care to have one
called, and at said time voice their views and desires on
this subject, and sign any necessary petitions required
by your office.

Thanking you very much for an early reply, I remain

Sincerely yours,

RDM/t

Shortly after his August 4, 1938, appointment, Reverend Wales was thrust into a politically sensitive subject. On January 16, 1941, Richard Morales again drafted a letter, above, to the postmaster general. (Late Albert Hatcher collection.)

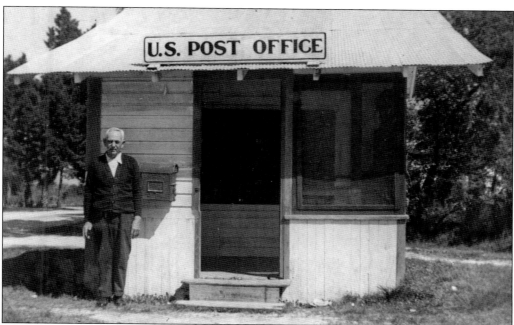

In the letter, a formal request for a name change from Hudson to Gulf Springs, it was not clear if Attorney Morales meant the post office or town name, and some questioned the intentions. An April 1941 letter indicates that a petition circulated resulted in four signatures because Reverend Wales "politicked" against it. The April letter states Wales's position was that a name change would result in residents paying to have their deeds changed to the new name. Attorney Morales further stated that the intentions were to only have the post office changed, not the town name. Regardless of reason, the request was denied and the town name and post office remained unchanged. The family in the bottom photograph are, from left to right, Florence Wales, husband John Wales, and daughter Charlotte. Not pictured is their son, Arthur Wales.

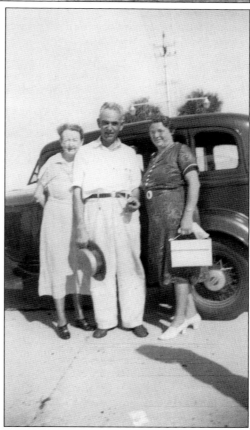

Hudson Post Office To Be Discontinued

Effective with the close of business on Monday, August 31st, the Hudson Post Office will be discontinued. This is in line with the policy of the Post Office Department in its endeavor to economize by discontinuing small offices. The patrons of the Hudson office will be served by the Rural Route from the New Port Richey Post Office, beginning Tuesday, September 1st. Mr. John A. Wales, the Postmaster at Hudson, is retiring, he having reached the maximum retirement age and having served over fifteen years in this capacity.

Serving for 15 years, Reverend Wales was the last postmaster of the historic Hudson Post Office. On August 24, 1953, the post office was discontinued, with services from New Port Richey effective August 31, 1953. Reverend Wales retired to Pensacola, passing away October 10, 1959. The envelope below shows how Hudson addresses appeared after the change, giving their location as New Port Richey, some 8 miles to the south. On December 1, 1957, the office was re-established as a rural station of New Port Richey and then Port Richey on May 16, 1959. As a rural station, the post office was located in the Hatcher Gas and Grocery Store, owned and operated by Albert and Fannie Hatcher, and later known as Sanchez Grocery, then owned and operated by George and Johnnye Hatcher Sanchez. (Below, Geraldine Hatcher Dougherty.)

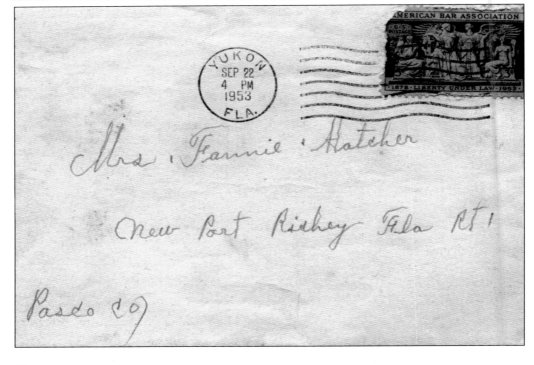

Four

SCHOOLS

Lang's School (No. 24) was constructed sometime around 1875, situated in north Hudson at Lang's Settlement. For 88 days a year, children gathered at the small one-room log schoolhouse, which was entirely community supported by residents giving land, building materials, and teachers' wages. Residents also recommended the teachers that would teach their children, and this same teacher taught all grade levels, primary and secondary, in the same one-room school. The rate of pay for a teacher was dependent upon the level of their teaching certificate from the school board: first class received $30, second class received $25, and third class received $20 per month. There have been a number of school lots, buildings, trustees, and teachers that have served the Hudson School since it first opened. Early trustees of the school, 1877–1887, included William Lang, William Graham Frierson, Jesse Hay, Daniel J. Strange (son-in-law to Hay), Martin Fillman, John William Hudson, and Constantine "Bud" Stevenson. Among the earliest recorded teachers were Capt. James McNeil, Benjamin Lee Blackburn, J. S. Bryan, and Henry Clay Bush.

On March 3, 1884, Lang's School became known as the Hudson School for a time, which by 1892 would become the school's permanent name, after being called Hudson-Hay for a time. By 1888, the original Lang's School gave way to a new building, which had been erected just south of Lang's Settlement in north Hudson. Graduation day brought celebration among the community as folks gathered at the schoolhouse for an afternoon fish fry and graduation celebrations, typically consisting of a full program involving the schoolchildren, parents, teachers, and school trustees. Today educational decisions no longer reside with residents but instead lie in the hands of the school boards who decide children's education, from where schools are built, who the teachers are, what children learn, and how much is given to education through taxes.

Deed No. 34

Know all Men by these Presents,

That the COOTY LAND AND IMPROVEMENT COMPANY, a corporation organized under the laws of the State of Florida, in consideration of the sum of _____ *One Dollar* _____

dollars, the receipt whereof is hereby acknowledged, doth, by these presents, grant, bargain, sell and convey unto *G. N. Bearden, J. W. Higgins, M. Jones, Stephen Wells & W. B. Hay comprising the School Board of Pasco County, Florida, and their Successors* heirs and assigns forever, the following-described lands, to wit: _____

Beginning at the South West Corner of the South West Quarter of the North East Quarter of Section Twenty three (23), Township Twenty four (24) South, of Range Sixteen (16) East, and running thence due North Five (5) chains to a Stake; thence due East Five (5) chains to a Stake; thence due South Five (5) chains to a stake; and thence due West Five (5) chains to the beginning, and _____

containing, according to the United States Surveys in the State of Florida, _____ *Two + $\frac{59}{100}$* acres, *Pasco* County, Florida,

To Have and to Hold unto the said grantee*s* ~~him~~ *Successors* heirs and assigns, forever. And the said grantor, for itself and its successors in interest, covenants to and with the said grantee*s* ~~their~~ *Successors* heirs and assigns, that it is lawfully seized in fee of the aforesaid premises; that they are free and clear of all incumbrances; that it has the right to sell and convey the same as aforesaid, and that the title to all and singular the said granted premises, it, to said grantee*s* ~~their~~ *Successors* heirs and assigns, against all persons lawfully claiming or to claim the same, or any part thereof, will forever **Warrant and Defend.** Attest the corporate seal of said corporation grantor, and the signature of the President thereof, this *Eighth* day of *February* A. D. 188*8*

After the Lang's School served for more than 10 years, another school was built. In March 1888, the Cooty Land and Improvement Company, who built the new school, presented their deed, for 2.5 acres, to Pasco County School Board. Since there were "two small schools in the vicinity, the board was of the opinion that it would probably be best to consolidate the two schools." On March 5, 1888, the board instructed the "superintendent to inquire into the matter," withholding acceptance of the deed. On May 7, 1888, "the Superintendent made his report in the matter of the Hudson School and it appearing that this school was located at a central point & convenient for the children living at or near Hudson, the deed for (2-1/2) two and one half acres of land from the Cootie Land Company, upon which is located the school house, was accepted and ordered placed upon record." This second school, called Hudson, was situated southeast of the Lang's School and at the current intersection of U.S. 19 and Bolton Avenue. (Author's collection.)

On February 4, 1889, a petition, specific in request, asked that a school be established near today's intersection of Hudson Avenue and Little Road. The board tabled the item, but lengthy debate about the location ensued among residents. Significant settlement had occurred near today's Hick Road and Hudson Avenue, which had the Vereen School. However, several were settling within the newly platted Hudson but their school was nearly 2 miles north. A committee formed seeking a compromise location, and October 6, 1890, a number of patrons of the Hudson School came before the board, after their committee had reached a decision. November 4, 1890, another deed from Cooty Land and Improvement Company, for 1 acre, was accepted for where the new school was located, Hudson's third-known school. Today this third school would be situated in the Highlands subdivision on Little Road. This location eventually proved to be too far from town, and the school was moved to a lot east of the Hudson Cemetery, the schools fourth-known location. Between July and November 1905, there was $140 in bonds issued to enlarge the school to the large house above. The horse-drawn buggy appears to be traveling south along the sandy trail, now Fivay Road north of Hudson Avenue. Behind the school was a sinkhole, now a retention pond along the road. For more than 40 years, a school sat on this location east of the cemetery. (Courtesy 1911 Port Richey Company Brochure, West Pasco Historic Society.)

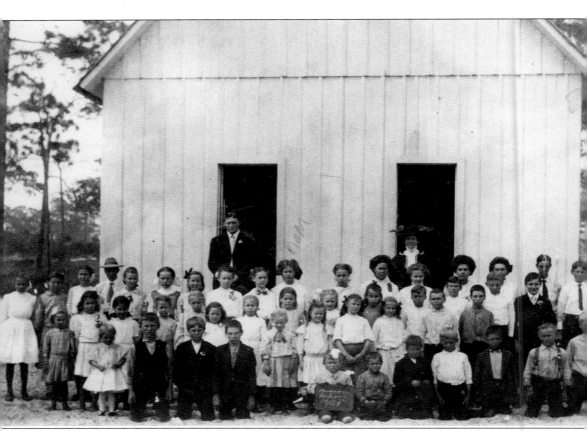

The enlarged school east of the cemetery was larger than the original one-room Lang's School, which had typical class sizes of 10 to 15. This April 2, 1909, photograph shows the increased class size and capacity of the enlarged school. From left to right are, standing in the back behind the children, William R. and Emma Terrill, husband and wife teachers; (first row) Oscar Brady holding sign, Jeff Youngblood, Leroy Pritchard, Leslie Knowles, unidentified, Richard Brady, and Willie Nelson; (second row) Vida or Alice Hudson, Clarence Brady, Albert Pritchard, ? Baker, Emma Knowles, Reba Overton, Rosa Leopold, Florence Leopold, and two unidentified; (third row) unidentified, Linnie Gomez, ? Baker, Lenora Edwards, Essie Knowles, Mildred Brady, Janie Edwards, Mary Youngblood, Ina Overton, Sadie Knowles, Bernard Hudson, Frankie Lewis, Bruce Moseley, Michael Knowles Jr., ? Baker, Woodie Overton, and Laudis Nelson; (fourth row) two unidentified, Bertha Pierce, Clarence Youngblood, Annie Leopold, Kate Overton, Leona Youngblood, Ruby Carter (Knowles), Geneva Moseley, Christie Bush, Nancy Susannah "Nannie" Knowles, Nellie Hay, Lillian Overton, Susie Brady, Belle Lewis, and Claude W. Hudson Sr. (Ann L. Knowles.)

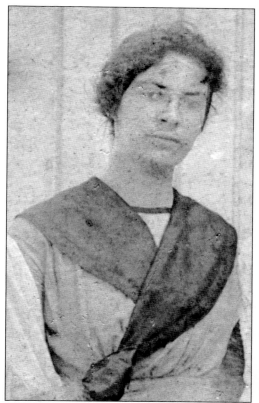

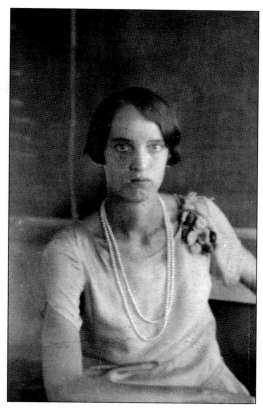

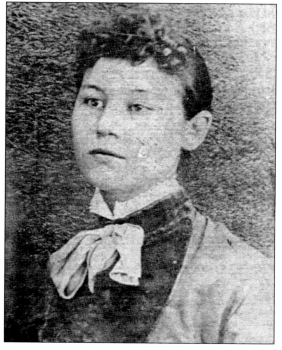

Early residents recommended the teachers they wanted to educate their children; however, as school boards were given more control, residents no longer had a choice in appointed teachers. As a result, some teachers had to travel great distances while being paid $20–$30 a month, and some schools saw several teachers in a scholastic year. Pictured are a few of Hudson's numerous teachers. Bottom right is Katherine Littell Riggins, daughter of George and Amanda Littell, who became teacher in August 1898 and was appointed principal in 1905. Above left is Winnifred "Winnie" Lee, who was assigned to Hudson in 1911 along with her husband, Bill Lee. Above right is Ila O'Berry Dowling, daughter of teacher and one-time superintendent Edmund Britton O'Berry from Blanton. Ila was assigned to Hudson in 1927, working with Katherine Littell Riggins, who was already assigned to the school. (Bottom right, late Mayhew E. Littell collection.)

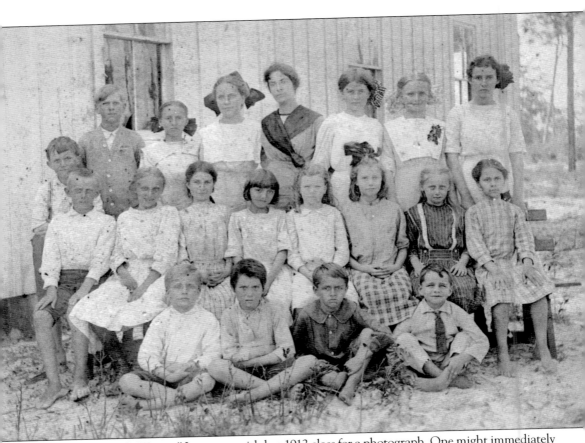

Here Winnifred "Winnie" Lee poses with her 1912 class for a photograph. One might immediately notice many of the children have no shoes; they were not required to wear any. Most families still made their own clothes, not because they were poor but because it was the way of life. It was a simple town and way of life where residents respected their school board, who supported their ideas of better education for their children. From left to right are (first row) Joe Gomas, unidentified, Earl Daniels, and Charlie Carey; (second row) twins Leslie Knowles and Essie Knowles (Hamilton), Linnie Gomas, Birdie Daniels, Reba Overton, Jennie Edwards, Emma Knowles (Brady), and unidentified; (third row) Oscar Brady (kneeling), Willie Nelson, Lucy Daniels (Hudson), Kate Overton, Winnifred "Winnie" Lee, Elvina "Vinie" Hicks (Knowles), Ina Overton, and Sadie Knowles (Sands) (Burton).

About 1925, Hudson received a new and much needed school building. For years, the old frame structure was repaired but eventually had to be replaced. In 1920, superintendent and board members inspected the Hudson school and "took note of the decayed conditions of the building roof." Retaining the lot east of the cemetery, the old frame house was replaced with the brick structure shown below with the Lysek children out front. The new school still had a tin-covered frame roof and wooden floors with crawl space underneath. With the new building came change in education as secondary grades were bused to Gulf High. In September 1923, the *Dade City Banner* reported "the Hudson School had grown to where it was found necessary to appoint a second teacher, resulting in appointment of Jennie Sheldon and Ida Mitcham. (Below, Hilma Lysek Tracey.)

WEST COAST SCHOOLS MAKE FINE PROGRESS

County Superintendent E. B. O-'Berry spent a portion of this past week visiting the schools of the west side of the county. The Hudson, New Port Richey grammar and Gulf High schools were all inspected. He reports that he found all pupils and teachers working together in an' enthusiastic and satisfactory manner and the results being obtained all that could be desired. The patrons of the different schools are all co-operating with the schools and there appeared to be no friction developing anywhere. The Hudson school has grown to where it was found necessary to appoint a second teacher, which has been done. —Dade City Banner.

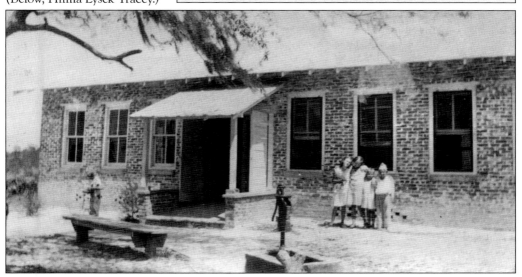

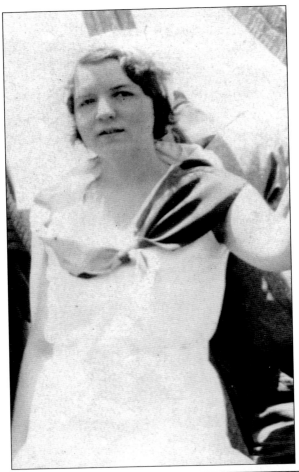

Katherine Littell Riggins was again appointed principal in 1926 and Miss Vahey assistant, while both taught the enrollment of 39. After Vahey was the appointment of Ila Oberry (1927), Florence Sessoms (1930), Florence Glass (1931), Bertha Norfleet (1933), and Lettie Endicott Bareford (1936). At left is the young and attractive Florence Glass, wife of Gulf Springs Lodge owner S. A. Glass. Below is Riggins with her entire 1934–1935 class, consisting of Esther Brady, Pearl Tindale, Eva Lysek, Bennie Booth, Elmer Hamilton, Martin Lysek, J. L. Bradley, Lonzie Hatcher, Logan Conner, Edward Tindale, Bryce Bliss, Hazel Booth, Rich Bradley, ? Bradley, Astrid D'Equevilley, Leona Knowles, Kristine Knowles, Elsie Fitzgerald, Joyce Bliss, Wilma Bliss, Peggy Matthews, Marie Lysek, Bruce Hamilton, Bruce Conner, Rudolph Fitzgerald, and Vernon Hudson. (Left, Annie L. Knowles; below, Hilma Lysek Tracey.)

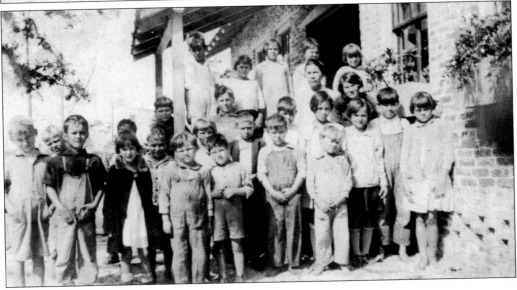

Pictured at right is teacher Lettie Endicott Bareford. Lettie was born December 13, 1891, in New Jersey to Franklin Endicott; there she worked as a teacher for 15 years before coming to Florida for health reasons in 1931. Lettie's father, living in Hudson, urged her to settle here. Before appointment to Hudson in March 1935, she worked at Elfers School while living in Seven Springs. Below, Lettie stands outside the brick school with her class of 26. From left to right are (first row) Bruce Hamilton, Clinton Conner, Rudolph Fitzgerald, and Vernon Hudson; (second row) Hazel Booth, Ruth Bradley, ? Bradley, Astrid D'Equevilley, Leona Knowles, Christine Knowles, Elsie Fitzgerald, Joyce Bliss, Wilma Bliss, Peggy Matthews, and Marie Lysek; (third row) Esther Brady, Pearl Tindale, Eva Lysek, Bennie Booth, Almer Hamilton, Martin Lysek, J. L. Bradley, Lonzie Hatcher, Logan Conner, Edward Tindale, and Bryce Bliss. (Both, James and Delores Fortner Sanchez.)

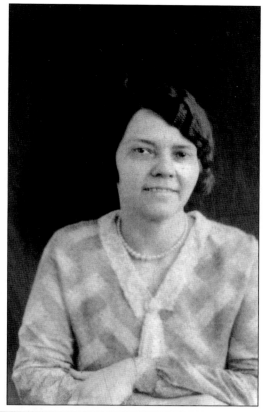

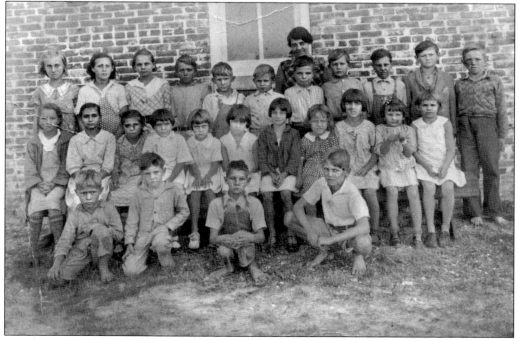

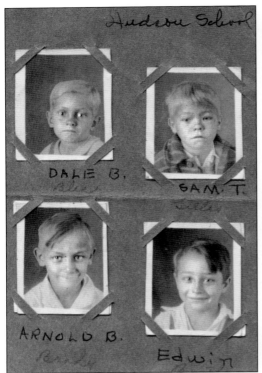

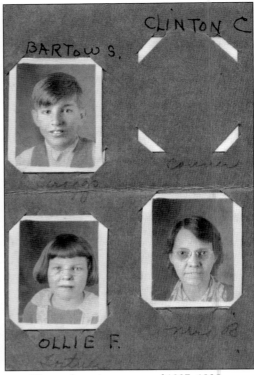

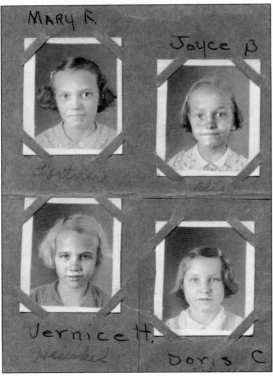

Shown here is a group of 1937–1938 individual portraits of Hudson School students. Very few of these types of photographs exist today, as most were separated from the small paper sleeves that held the pictures together, with the student names written above and below. The small Hudson student body was actively involved with their school and community while residents supported, wholeheartedly, the student body. (All, James and Delores Fortner Sanchez.)

March 2, 1938 - By the Fifth Grade
Wilma Bliss
Elsie Fitzgerald
Clinton Conner
Bartow Scroggs
Milton Stevenson

School News

Our attendance has been very good until February. Many have had bad colds. Now an epidemic of Mumps has broken out. We hope it will not spread and make our attendance any lower.

Clinton and Doris have been absent two weeks because their brother had the Mumps. They have the disease now and will have to miss several more days. We hope they will all soon be well again.

Bartow returned to school today after two-weeks absence. He was under the doctor's care and needed rest and quiet. He looks much better. We are glad to have him back with us.

Dixie had the misfortune to tear open his ankle with a nail making a bad wound. He has not been able to attend school this week. We hope he will soon be back with us.

During the week of February 22nd, we made booklets in memory of our first president and "Father of Our Country". We colored cherries and a hatchet; the colt; the Liberty Bell. We wrote a story of Washington's life and cut out a picture of Washington crossing the Delaware. We pasted these in our booklets.

On the afternoon of Washington's Birthday we made syrup candy. While the candy was cooking, Edwin fell on the concrete walk and cut his chin quite badly. While Mrs. Bareford was taking care of him our candy scorched. We ate it though, n called for more.

Other News

On Friday, February 18, the Methodist Church burned to the ground. They were unable to save anything. Someone was burning weeds and a strong wind swept the fire out of reach. It crossed the road and in a few minutes the church was a blaze.

Our school was used to hold services for two weeks. Now they have put the unused desks from our school in a building on the main road opposite the Post Office. This will be used for a church for a while.

Personal

WHAT WILL HAPPEN -

When Arnold knows his spelling?
When Rudolph knows his lesson?
If Edwin should get a low mark?
If Vernice should get a D?
If May Frances should stop talking?
If Elsie sits still?
If Nan stops telling?
If Wilma studies her History?
If Dixie should work hard?

Sports

We play many kinds of games. Sometimes the boys and girls play baseball together. There are not enough pupils to have a team of all boys.

Pictured here is the only surviving copy of a Hudson School newsletter, which was published by the 1938 fifth-grade class, one of the many activities that Hudson's dedicated teachers planned for students to keep them involved and occupied beyond their normal curriculum. In addition to reporting school events, students also reported on the community, such as the Hudson Methodist Church fire in March 1938. For two weeks after the fire, the brick school was used for church services until parishioners acquired another location. (Hilma Lysek Tracey from Bareford collection.)

HUDSON SCHOOL HOUSE BURNS

Fire of undetermined origin destroyed the school house at Hudson on Monday afternoon shortly after 5 o'clock. The New Port Richey fire department was called to the scene and arrived quickly, but were unable to stem the blaze.

The Hudson school taught up to the 7th grade.

Some residents still remember attending classes at the brick school east of the cemetery. On Monday, May 21, 1945, the small school caught fire and was completely destroyed, as reported in this *New Port Richey Press* article. While constructed of brick, the school still had its heart-pine floors, framed tin roof, and its wooden doors and windows, which were consumed while the intense heat weakened the brick and mortar. Since Hudson had no fire department, the fire was reported to New Port Richey nearly 10 miles south of the scene. At the loss of the schoolhouse, residents circulated a petition, shown on page 81, asking the school board and trustees to rebuild their school quickly using the collected insurance money from the fire; residents assured all cooperation. Most residents were against consolidation and the busing of their children to other schools; they wanted their own school.

(COPY)

A-PETITION
TO:

The Hon. R. D. Stevenson, Member of
the Pasco County School Board; and,
to the Trustees of Schooldistrict No,3,
Pasco County, Florida.

Gentlemen:
We, the property owners, tax-payers, and citizens of the
Town of Hudson, having suffered the great loss of our Public School
building by fire of some unknown origin; and, while realizing the
great scarcity of building materials of nearly all kinds in these days
of stress because of the war; we still recognize the fact that even
wars cannot be intelligently prosecuted without trained and skilled
men and women to direct successfully its progress at all its stages;
THEREFORE, to obtain this leadership, it is obvious that our children
must not be deprived of the advantages of Primary School facilities,
such as can only be obtained in the Local Community School.

FURTHER, we recognize the advantages of the consolidated school
as advocated by so many, and this is true for the children of advanced
age and learning, but the consolidated school cannot, and does not
meet the requirements of the little children beginning their school
life in the Primary grades. The Local School meets every need of the
beginner.

THEREFORE, we, the property owners, tax-payers and citizens of the
Town of Hudson, Pasco County and State of Florida, earnestly petition
you gentlemen of the Pasco County School Board, and our Trustees of the
School District in which this great loss has occured, to use the
insurance money you may receive account of the loss, and begin the
re-building of our School just as quickly as is possible. And, you
can be assured of every co-operation possible on the part of all our
Townspeople. We stand ready to do all in our power to help replace
the building. x and to this end we attach hereto our several names:

The school board agreed to rebuild the Hudson School; however, residents were required to
donate, to the school board, a new lot located near the center of town. Residents were clear in
their petition that they were against school consolidation for the "little children" in the primary
grade. (Late Albert Hatcher collection.)

81

Hudson, Florida
February 21st 1946

TO WHOM IT MAY CONCERN: GREETINGS:

We, the undersigned Citizens, residents and taxpayers of the TOWN OF HUDSON, PASCO COUNTY, FLORIDA hereby contribute the amounts set opposite our names below for the purpose of buying a lot or parcel of ground in the Town of Hudson upon which the School Board Members agree to BUILD OUR HUDSON PUBLIC SCHOOL, replacing the old School which burned recently.

The amount of TWO HUNDRED DOLLARS is required, and it is hoped that every resident of our Town will cheerfully do his or her part in a most generous spirit of public welfare. Come on! Let's Do It!

Name			
A. J. Hatcher	10.00	C E McClamma	2.00
Walter Bliss	10.00	Dave Ashburn — Dixie Lily Milling Co.	1.00
C. P. Germans	10.00	Harold Billingsly	5.0
J L Barrell	10.00		
W F Hudson	10.00		
Carl Hatcher	10.00		
Willie C Baker	10.00		
L. A. Fitzgerald	10.00		
Robert Hunt	1.00		
L. B. Fletcher	2.00		
Marshall Wiley	1.00		
J. J. Knowles	1.00		
Marks Hatcher	10.00		
Curtis Green	5.00		

By February 1946, Hudson's residents responded to the school board's request for another lot with yet another petition (shown here). This petition allowed residents an opportunity to contribute money "for the purpose of buying a lot or parcel of ground in the Town of Hudson upon which the School Board Members agree to build our Hudson Public School."

	
Clarence	10.00
Essie Hamilton	2.00
Henry Hunter	10.00
Woodrow Brady	3.00
Worksey Knowles	10.00
W. A. Conner	10.00
Tom Brady	.00
Fred Baker	10.00
Robert Hatcher	10.00
Louis Fitzgerald	5.00
Mrs. Knowles and Raymond	5.00
Gene Rossi	10.00
Richard Brady	5.00
Jasper Wilson	1.00
John Q. Wales	5.00
J. J. Booth	2.00
E. J. Booth	5.00
J. A. Rich	2.00
Tom Pritchard	1.00
Remy Fitzgerald	1.00

Total to be built on

7d Grey — 82	15.00
Walter Bliss	25.00
Aaron Gillett	15.00
W. A. Conner	20.00
Fred Baker	15.00
Willie Baker	15.00
Curtis Milene	1.00
C. A. Mathis	2.00
Wm. Cutting	0.00
Carl Hatcher	20.00
Oscar Brady	5.00
Ja. J. Farrell	9.00
Ja. Hatcher	25.00
B. V. Stevenson	16.00
J. J. Booth	10.00
John Q. Wales	5.00
C. W. Brady	4.00
	252.00

The collection of $200 proved residents cheerfully cooperated through their financial contributions and generous giving toward the purchase of the new school lot. Some residents were so generous that they contributed to the fund more than once, as shown above, and left, from the actual figures collected. (Late Albert Hatcher collection.)

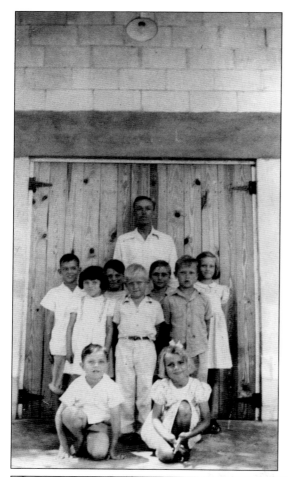

August 1946 newspapers reported a school lot had been acquired while board members reported "work on a building to replace the school house lost by fire some months ago would be started immediately, and an endeavor would be made to have it ready for the next school term." Pictured left is the 1947 first-grade class, and below is the entire 1947 student body of 21, both with their teacher Karl E. Parks III; the first group of students is in the new school. Those first graders pictured are Edmund Cupp, Annease Baker, Rufus Yeomans, Billy Gode, Dewey Hunt, Winfred Harrell, Ray Gillett, and Bernice Baker. Not all of those pictured below have been fully identified, however; notice the homemade doors that were temporarily installed as to not delay the opening of the school. (Both, James and Delores Fortner Sanchez.)

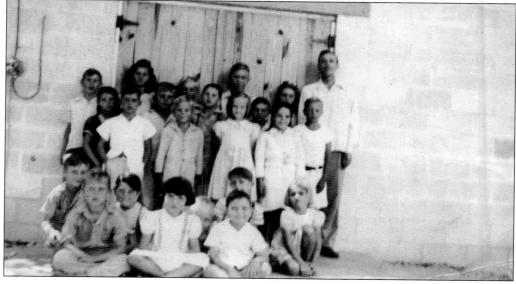

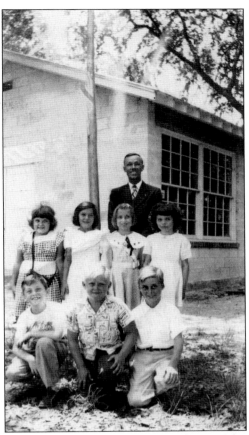

The new lot in the west half of lot one, block 12 of the town's plat, consisted of 1.5 acres. These photographs taken June 3, 1948, show the second-grade class, many of those pictured on the previous page in first grade. Notice the school board replaced their homemade doors with typical primed white doors. However, the school was not yet painted and here the cinder-block construction is shown. Pictured above are David Braswell, Winfred Harrell, Dewey Hunt, Nancy Green, Bill Gode, Patricia Hendry, Bernice Baker, and teacher Karl E. Parks III. Below are Dewey Hunt, Rodney ?, Winfred Harrell, Eddie Martin, Bernice Baker, Nancy Green, and Delores Fortner, all wearing shoes. Today the small schoolhouse still stands at the corner of Water Tower Drive and Apple Street; however, the future of this historic schoolhouse remains uncertain today having never been declared a historic structure by Pasco County. (Both, James and Delores Fortner Sanchez.)

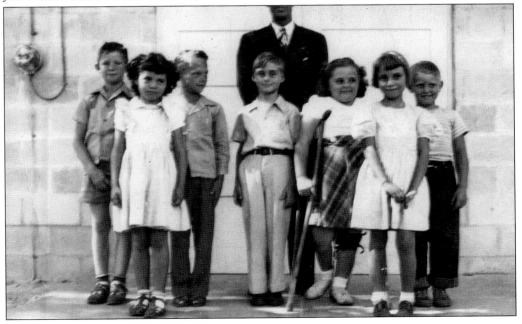

Board May Open Hudson School

DADE CITY — The County Board of Public Instruction yesterday agreed to reopen the Hudson School closed last month due to low attendance. A delegation from the community protested the closing, claiming that the rapid growth of the community would make a school compulsory under state law within a short time.

The board agreed to hold a school registration Saturday at the Hudson School and if 17 or more students register, the school will be reopened but will remain open only as long as the attendance holds about the 17 minimum.

After dropping attendance, the board closed the school August 24, 1955; however, after protest, it agreed to reopen the school as reported in the September 14, 1955, article (left). By 1962, student population grew with the school becoming too small, evident to everyone except board members. A bond issue for new schools in western Pasco was defeated because there was no provision for a school in Hudson. After amendment to include facilities for Hudson, the bond was again submitted to voters and passed. The school board still dragged their feet until Hudson residents threatened suit to stop all school construction unless Hudson was included as voted. With 12 classrooms, Hudson Elementary School opened for the 1967–1968 term with 314 students. In 1962, the former school lot and building was sold to the same residents who donated it to the board in 1946. When purchased, the building was for public use as the Hudson Community Club, who chartered in 1955 and dissolved in 1974.

Hudson School Building Sold To Citizens' Group

The old elementary school at Hudson was sold by the board of public instruction at their meeting on Tuesday to an organized group of citizens from the West Coast community.

The vacant school building and 1.5 acres of land, which has not been used to school purposes for the past six years, was sold to the Hudson Community Club, Inc., for $2,250.

The sale of the property has been pending for the past several months. Action by the board was stimulated Tuesday when a large delegation representing the club attended the meeting and presented a petition signed by 137 residents of the Hudson area requesting the board to sell the property.

The original offer by the Hudson Community Club was to purchase the property for $3,500, with the board granting a five-year lease-purchase option on the property for $500 which would be applied to the principal, if the club completed the purchase transaction within the five-year period.

The board, feeling that it would be improper to sell the property without obtaining a true assessment of its value, had an appraisal made of the building and grounds and found that its value was only $2,250.

The delegation, therefore, offered to either abide by their original offer, or to purchase the property for a cash price of $2,250, which would leave them in a better financial condition to replace the roof and do other renovation work on the building.

Thomas Sawyer, spokesman for the delegation, explained the purpose of the Hudson Community Club, Inc., and told of projects undertaken to aid and promote the growth and development of the community. These projects include an entire water supply system for Hudson as well as providing picnic and beach area for the residents and visitors.

The spokesman said it was the desire of the club to have the old school property for a community center. They plan to spend an initial $1,500 in repairs of the building and development of the grounds.

The building will be open to the public as long as it is used in an orderly manner, with no alcoholic beverages allowed.

The building will also be available for political rallies, use as a voting precinct, etc.

Five

EARLY CHURCHES AND RELIGION

In 1938, Joseph Byrd Hudson wrote, "We have a large percent of people here in Hudson that are 'very Religious,' I mean they are Fanatical in their religious conduct." The first church was established in 1881 with a movable pulpit in the original Lang School, a regular stop on a preaching circuit with an itinerant minister. In 1882, the small congregation of nine established the Good Hope Baptist Church with Rev. Daniel McLeod as their pastor and Robert Madison Hill the representing delegate to the conference. The small congregation soon constructed a pitch-pine building on Hudson Avenue. While regular services had been scheduled the second Sunday every month, by 1887, the church was closed and consolidated with other nearby congregations.

Hudson's second established congregation was the Methodists, who, in 1898, also constructed a church on Hudson Avenue. This new church was a grand frame building complete with bell tower. On December 18, 1898, Rev. Jesse M. Mitchell was appointed their first pastor by the Methodist Conference, South.

Around 1914, the Hudson Church of God was established, and in March 1919, the congregation acquired its first lot, situated just south of Old Dixie Highway and Hudson Avenue. Following acquisition, construction of the first building commenced. While small, the simple one-room church building served their congregation for many years.

In 1945, part of the Methodist church congregation saw need to establish their own church and the group formed the Community Church of Hudson. In the spring of 1949, there arose a division within the small Community Church, and a group of members again recognized a need for the formation of another church congregation. On April 18, 1949, this group held their first meeting to plan the organization of the new church and by June had decided on the Baptist denomination. This church is known today as the First Baptist Church of Hudson. Only the Methodist, Baptist, and Church of God congregations remain today, serving and supporting Hudson's spiritual needs.

STATISTICS OF THE CHURCHES.

CHURCHES.	PASTORS.	CLERKS.	CLERKS' POST OFFICE	MESSENGERS.	Baptized	Received by Letter	Restored	Expelled	Dismissed	Dead	Loss	Gain	Total	Clear Gain	Contributions	Sabbath Schools	Sabbaths of Meeting
Anclote				Not represented													
Bethel	W. W. Bostick	J. A. Hancock	Lakeland, Fla.	E. G. Wilden, J. W. Tucker	8								78	8	17 00		4th
Bartow	W. W. Bostick	B. F. Blount	Bartow,	J. C. Blount, J. M. Hayman									26		74 15		2nd
Beulah	W. W. Bostick	W. T. Denham	Fort Meade	R. N. Pylant, W. T. Denham	3	4	2	8		5	9	20	4	12 16	1	1st	
Bethany				Not represented											8 25		2nd
Clear Water	C. S. Reynolds	W. J. Taylor	Clear Wat'r, Fla.	By letter	2			1	1		2	15				4th	
County Line	R. T. Caddin	J. M. Godwin	Disston,	By letter	2								1 00		4th		
Double Branch	J. T. Pittman		Fort Dade	W. R. Smith												4th	
Emmaus	J. T. Pittman		Fort Dade													4th	
Fellowship																	
Gapway	G. M. T. Wilson	J. L. McClelland	Madulla, Fla.	E. Combee, J. L. McClelland	4	4				4	5	44	1	1 50		3rd	
Good Hope	D. T. McLeod	J. B. Hudson	Hudson,	By letter	6							19	7			3rd	
Hopewell	T. H. Jandon	J. R. McDonald	Alafia	W. F. Frierson, W. M. McDonald	3	1					5	61	5	5 20	1	1st	
Hebron	G. M. Wilson	N. A. Williams	Brooksville,	M. W. Page, A. A. Ball	1	1					2	12	2	2 25		4th	
Key West	W. F. Word	John V. Johnson	Key West		50	8	4	25	1	8	29	61	33	5 00		Each	

Hudson's first church was constructed of pitch pine and located near the northeast corner of Hudson Avenue and Old Dixie Highway. In 1882, this church received Rev. D. T. McLeod as its first pastor, with services held once a month as reported by delegate Robert Madison Hill. The 1884 records above report the church was called Good Hope and baptized six members into its growing congregation of 19, with Joseph Byrd Hudson as the clerk. In 1886, fourteen members were reported under Rev. B. S. Ray, the last report for the church perhaps after it consolidated with other nearby churches, such as Bethlehem, established in 1885. It's also possible that they joined a different association.

Abbott									
Richland	2	9	2			1	17	20	450 00
Tarpon				3	3		8	14	
Withlacoochee	1		4	4	4		29	34	60 00
Six-Mile-Pond				2			14	25	600 00
Bay Lake									
New Hope									
Good Hope		2					9	7	225 00
Clay Sink		1	1	4	1		17	15	
Total	20	31	4	36	18	6	243	307	$1 115

In 1899, the Good Hope Baptist Church reappears in Association Records with two members "received by letter" and a congregation consisting of 16 members: 9 males and 7 females. There was also the addition of Sunday school classes with 20 pupils and Mosley as the superintendant. By the 1920s, Good Hope had ceased and Hudson residents went to either the New Port Richey or Aripelca Baptist Churches. (Patricia Bronson.)

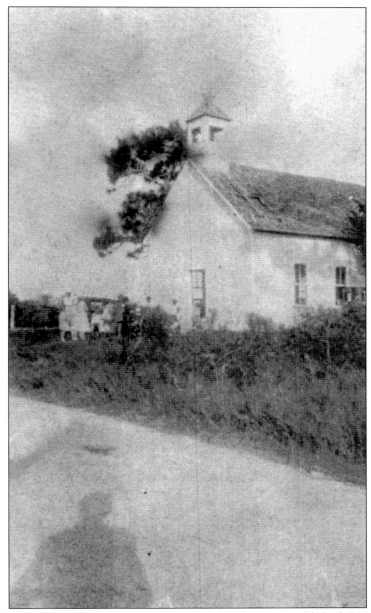

In 1898, Hudson's first Methodist congregation and church were established. Many comprising the new congregation likely attended the nearby Vereen Methodist Church, 4 miles east. After acquiring a lot at Hudson Avenue and Guava Street from Mary A. K. Osborn, the congregation started constructing a building. Pictured is the typical but grand and magnificent building constructed for the new Methodist congregation, complete with bell tower. On December 18, 1898, Rev. Jesse M. Mitchell was appointed pastor by the conference, followed by Rev. M. T. Bell, 1899; Rev. Tom McMullon, 1901; Rev. W. F. Fletcher, 1902; Rev. R. H. Barnett, 1903; Rev. W. H. F. Robarts, 1904; Rev. K. M. Albright, 1905; Rev. K. D. Jones, 1906; Rev. J. M. Diffenworth, 1907; Reverends Combs, Willis, and Mitchell shared duties 1908–1909; and Rev. J. D. Frierson, 1910–1911. (Late Ella Gay collection.)

The revival services held in Hudson M. E. church from Aug. 22 to Sept. 5 by the Rev. J. M. Mitchell of Elfers, was a real revival of Christian interest, more than of conversions. There was a good attendance throughout, with capacity congregations Sunday. This meeting is being followed by a woman's prayer meeting on Tuesday afternoons, that is of much interest.

Claude Mitcham and helpers are

On Sunday, November 9, 1923, three Methodist churches comprising the local circuit gathered in Elfers for their first "Rally Day Services" with dinner on the grounds, followed by entertainment from the Clearwater Methodist Sunday School Orchestra. In 1926, the Hudson church hosted a revival, perhaps the first in Hudson. Services preached by Reverend Mitchell were reported in the *Dade City Banner* (above), and the grand Hudson church was filled to capacity. July 22, 1927, newspapers reported the congregation received a new pastor, Rev. and Mrs. Cotton, welcoming them to the community like any new pastor. After the Great Depression, all churches were struggling and efforts to encourage weekly offerings were implemented through distribution of offering envelopes. In December 1932, Christian education was preached throughout the circuit, and the first Sunday School Day was recognized followed by spring revival Vacation Bible School in 1933.

Pastor Received Good Pounding

Our new Methodist pastor and his wife, Rev. and Mrs. Cotton were welcomed with a reception and party held at the home of Mr. and Mrs. Knowles Thursday evening. Music and conversation was followed by the serving of delicious cake and punch. The pastor and his wife received a "good old fashioned pounding," and expressed great appreciation of the same.

On Friday, February 18, 1938, a neighbor was burning weeds when strong winds swept the fire across the street. Within minutes, the grand Methodist church was a blaze. March 30, 1938, assistant pastor John Wales reported to the conference, "Our church building was destroyed by fire—building and entire contents a total loss." For two weeks after the fire, services were held at the school east of the cemetery while fund-raisers were planned, as the *New Port Richey Press* reported April 12, 1938. These rallies were common events in Hudson, as shown below in the 1940s. Arrangements were soon made with Willie and Ruth Knowles, who owned the old Good Hope Church building, still at Old Dixie Highway and Hudson Avenue. With several unused school desks, the old building again served as a church.

BASKET PICNIC AND POLITICAL RALLY PLANNED

New Port Richey, April 12.—A combination basket picnic, old-fashioned fish fry and a political rally will be held at Hudson next Saturday, to which the public is invited. Various candidates, who are seeking office in the coming election, will be on hand to state their views and meet the voters. The proceeds from this picnic and fish fry will be used toward the building of a new church to take the place of the Methodist church that burned to the ground Feb. 18. Those attending will bring a basket of food, tables will be supplied free, and fish, coffee and bread will be sold by the women for a nominal sum.

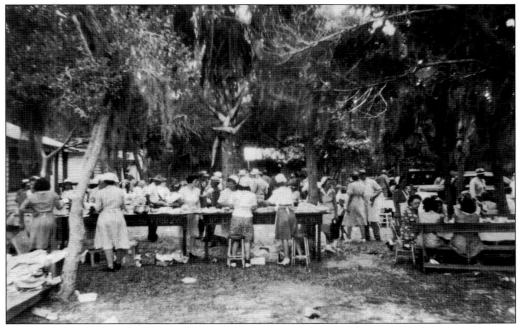

CHURCH OF GOD WARRANTY DEED

This Indenture made this the __27th__ day of ____March____ A. D. 19 __19__. Between
Mrs. Mary S. Brady, widow of William Brady
Mrs. Sarah S. Gomez, daught. " " " " " " of the county of ____Pasco____
Mrs. Mary E. Knowles, " " "
and state of ____Florida____ part __ies__ of the first part. And __W.S. Knowles and T. W. Brady__
____and Thomas Pinder _____ Trustees of the Church
of God, at ____Hudson, Florida_____, parties of the second part.

Witnesseth that the said part__ies__ of the first part for and in consideration of the sum of ____
____Twenty Dollars_____ ($20.00 ____) in hand paid, the receipt of which is here
by acknowledged, have granted bargained sold and do hereby sell and convey unto the said parties of the second
part the following real estate to wit:

____Commencing at a point one-hundred and five (105) feet south of the____
north-east corner of Lot One (1), Block Nine (9), town-plat for Hudson,
Florida, Section twenty-eight (28), Township 24 South, Range Sixteen (16)
East, and running thence South fifty0 (50) feet, thence west one hundred
(100) feet, thence north fifty (50) feet, thence east one hundred (100)
feet to point of beginning: the above described lot is in Lot One, Block
nine.

To have and to hold the same as such trustees and their successors in office or assigns forever to be held
in trust by them for the use and benefit of the above named **Church of God** with the ministry and membership
of the General Assembly of said **Church of God** with headquarters at Cleveland, Tennessee.
It is especially understood and agreed that if for any reason the above church or its trustees should
cease to do business then the trustees of the said General Assembly shall become their legal authorized succes-
sors subject to the orders of the said General Assembly of the **Church of God.**
The first part__ies__ hereby releasing all claims to homestead and dower therein and covenant they are
lawfully seized of said real estate and have full power, authority and right to convey the same, that said prem-
ises are free from all incumbrances

and that____they____ will forever warrant and defend the title thereto against the lawful claims of all persons
whomsoever.
In Testimony Thereof, we ____ have hereunto affixed our signatures on this the __27th__ day of
____March_____ 19 __19__.

____B.F. Pritchard____ Witness. Mary S (X) Brady
____Ellen G. D. Vries____ Witness. Mrs Sarah S Gomez
Mrs Mary E. Knowles.

Around 1914, Church of God evangelist Rev. Lula Roberts arrived in Hudson by boat from Tarpon Springs on her quest to establish churches throughout the area.

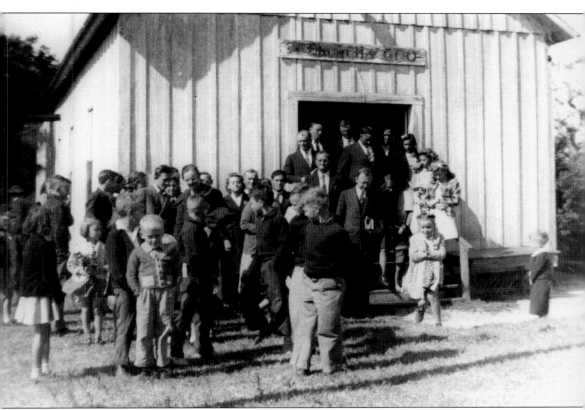

For nearly five years, services were reportedly held outdoors until a church was constructed for the Church of God congregation. On March 27, 1919, Mary S. Frierson Brady, widow of William Brady, and her daughters, Sarah S. Gomez and Mary E. Knowles, deeded a lot to Woolsey S. Knowles, Tom W. Brady, and Thomas Pinder, trustees for the Church of God at Hudson, for purposes of building a new church. After acquisition, construction started on a frame church building, similar to most around town. This small church was just south of the southwest corner of Old Dixie Highway and Hudson Avenue, and behind it was a frame parsonage where the pastor lived, readily available to his congregation. (Gloria Surls.)

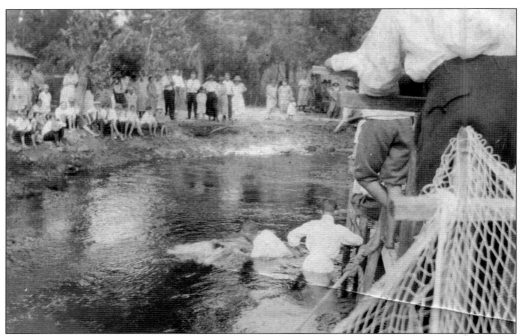

When it was time to baptize new members into the Church of God, the entire congregation made their way to Hudson Spring, utilized for the earliest baptisms by the church. Pictured above is an early church member being baptized in Hudson Spring as the congregation gathered around; notice the net spreads in the foreground where church members stand for a better view. In later years, baptisms were conducted in Hudson Creek downstream from the spring at Guthrie's Dock, located along a then-sandy trail now known as Kulig Court. Entire Sunday afternoons were dedicated to church, with Sunday school, preaching all day, and baptisms in the spring or creek, followed by a potluck dinner on the church grounds (shown below). It was a time of singing, worship, prayer, and fellowship for the congregation, both young and old. Some residents still reminisce about these gatherings long ago. (Gloria Surls.)

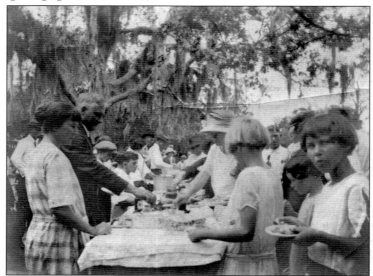

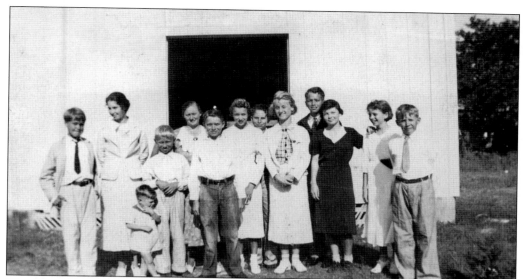

The Church of God endorsed worship and fellowship among the young folks through Sunday school and youth groups, as did the Methodists. Above, the Hudson Church of God Young Peoples Endeavour (Y.P.E.) Convention of 1937 stands in front of the original Church of God building. The Y.P.E. was a Vacation Bible class, teaching the Bible to the young people. The congregation soon outgrew its simple frame structure and sometime in the mid-1950s constructed a new cinder-block building on the same lot. Pictured below is the Church of God Sunday school class seated inside their new block building. This building served the congregation until 1976, when trustees purchased property on New York Avenue, where the church resides today. While not used as a church anymore, the old block building still stands, now a deli store. (Below, Alice Hatcher.)

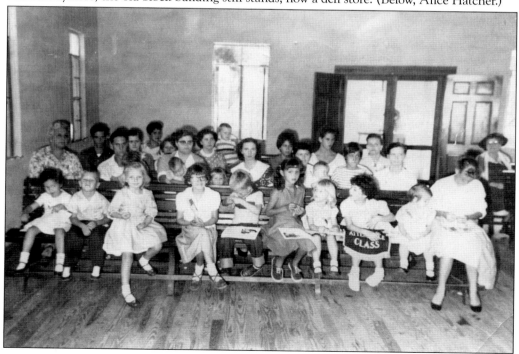

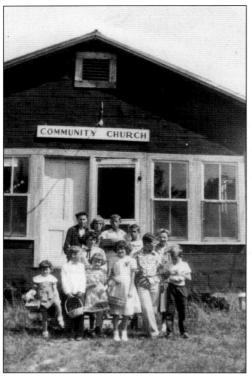

Around 1941, assistant Methodist pastor John Wales decided to change the church from Methodist to nondenominational to better serve those in his charge. At that time, the Methodists occupied the former Good Hope building on the northeast corner of Old Dixie Highway and Hudson Avenue. As a result, the small building became the new Community Church, pictured here with the small congregation standing in front. The building was more than 60 years old and in a weathered condition. The board-and-batten siding was covered with tar paper to prolong the old weathered building. In June 1949, Ruth and Willie Knowles donated the lot to a new Baptist congregation and the building was moved one block east to Guava Street and Hudson Avenue. (Both, James and Delores Fortner Sanchez.)

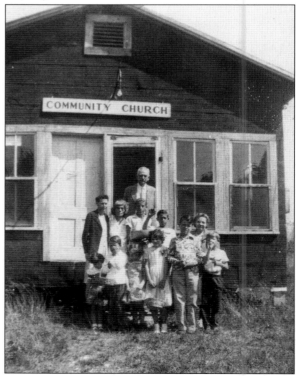

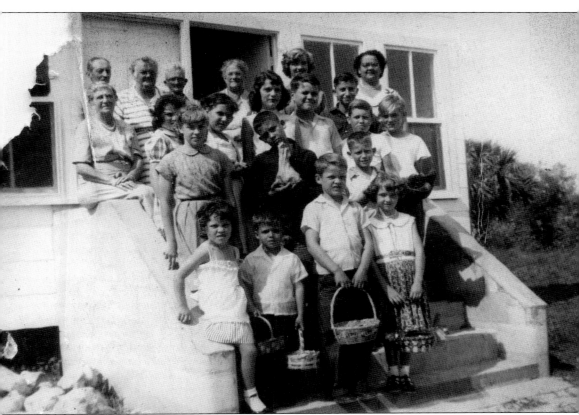

After being moved, the church was remodeled. The tar paper was covered with asbestos siding, which gave the building a new appearance. A set of block steps was made wide enough for the double doors. In 1953, Reverend Wales retired, and in 1959, the Community Church decided upon the Methodist affiliation under direction of Rev. Charles Green, with the congregation of 22 holding services in this building until 1959, when they subsequently decided to build a fellowship hall. This new hall, then located at 109 Hudson Avenue, became the Methodist congregation's new church until 1972, when they moved to their current location on today's U.S. 19. Their former fellowship hall still serves the community as a church. The former Good Hope Baptist Church building was condemned and razed in the early 1990s, one of the community's most historic structures. (James and Delores Fortner Sanchez.)

In 1949, a division arose within the Community Church, some recognizing the need for a new church. At their first meeting, they elected Ruby Knowles, secretary; Eunice Heinkle, treasurer; and Tom Brady, Sunday school superintendent. Henry Heinkle, Tom Brady, and Ben Sibley were acting trustees. After several meetings, Baptist affiliation was unanimously decided, forming the First Baptist Church on June 2, 1949. Ordination services were held on the northeast corner of Old Dixie Highway and Hudson Avenue, the location of the former Good Hope Baptist Church. Willie Baker, Tom Brady, J. L. Harrell, and Henry Heinkle were ordained first deacons and Rev. Charles Sherlock as first pastor. On June 29, 1949, Carl Mountain delivered building materials from Brooksville, and a foundation was laid by the Nichols brothers on July 14, 1949, with members and friends assisting in construction. In 1965, the church was enlarged, and the original church constructed was incorporated into the new building designs and is also shown toward the back of the building, as pictured here.

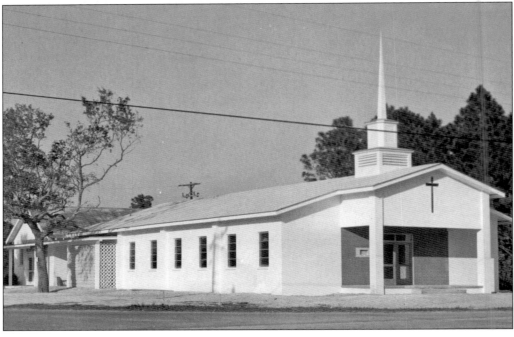

Six

HUDSON SPRING AND CREEK

From the spring and through its once flowing creek, Hudson was linked to the Gulf waters, an early lifeline for the coastal community. However, the spring no longer flows because area sinkholes were filled during development, cutting underground flow from its source at Bear Sink. With the burning of the Hudson Mercantile Store about 1890 came new commercial growth surrounding Hudson Spring. Marquis L. Moseley acquired property and built a new store and Hudson's first hotel overlooking the spring. Guests at his hotel had the convenience of his store and access to the spring and Gulf waters. Down the creek, on Cotton Island, residents built bathhouses where folks could picnic and bathe in the warm Gulf water. All along the banks of the spring and creek, fish houses were built, each with docks to anchor the fishing boats and "net spreads," where the fishing nets were spread for drying or mending. The first explorations into the dredging of Hudson Creek were through the river and harbor act adopted March 3, 1899, authorizing a survey of the bay at Hudson, Florida; however, dredging did not occur until the 1950s by private enterprises. With the arrival of the railroad to Hudson in 1903, a depot was built north of the spring and Moseley's hotel and store followed by the addition of a telegraph office and Littell Sons Store. Hudson's commercial district was growing fast.

Today it is hard to imagine this once thriving commercial district. Those early buildings that once surrounded the spring are no longer; in their place are the modern mobile homes of Hudson Springs Mobile Home Park. Through privatization of the Hudson Spring, residents were no longer allowed access to the spring, and this area of business and leisure soon became history. Today few know of its existence and importance to the early community.

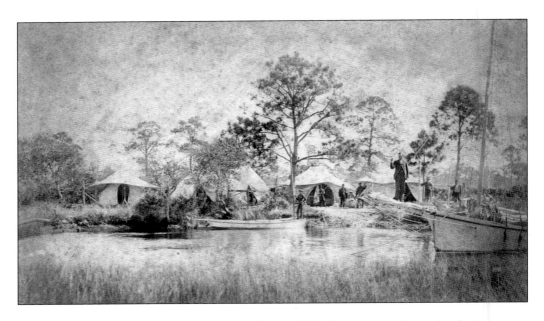

Very few early images of the spring survive, making it difficult to imagine the early life of pioneers. This, the earliest known photograph of the Hudson Spring, dates to about 1881–1882; here one can see what the Hudson family found arriving at the coast in 1878. The sloop anchored at right may be the Hudsons' sloop, which was operated by young Joseph Byrd Hudson (believed to be standing on the bow). The sloop was traded for two oxen, which Isaac Sr. had given to the previous owner, a Mr. Hall of Bayport. The white tents belong to what appears to be a survey crew of five men; notice the men in the middle standing next to a tripod and beside a man with a rifle, likely the camp cook. Behind the sloop, on the right, are what appear to be the chainmen holding their ranging rods. (Camille Coors.)

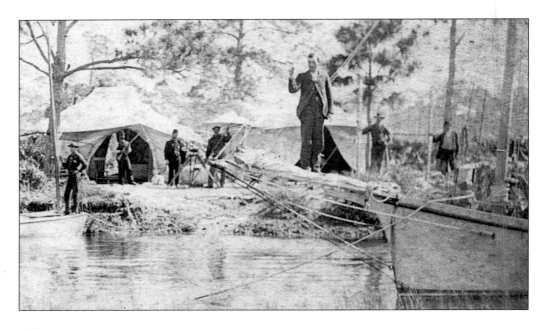

Right, Salem Hatcher stands aboard a houseboat in front of Moseley's hotel, built in the late 1890s, Hudson's first hotel. It became a gathering place for social events such as ice cream socials, fireworks, square dancing, chicken dinners, fish fries, and political rallies. When this photograph was taken in the early 1920s, the hotel had fallen into disrepair. Below is a view of Hudson Spring at low tide with natural lime rock formations exposed. What looks like docks are net spreads, where nets were mended. In the distance is Cotton Island, named for the cotton that grew wild there. Cotton Island later became known for its bathhouses where it is said Hudson's seafaring men stopped to clean up before coming into town; others used them for recreation. (Above, the Hatcher family.)

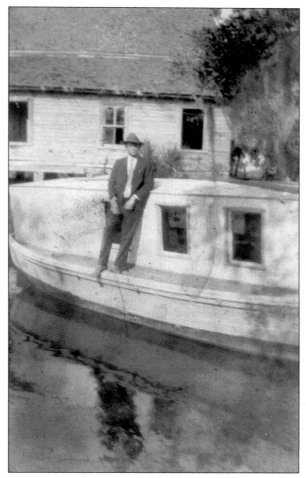

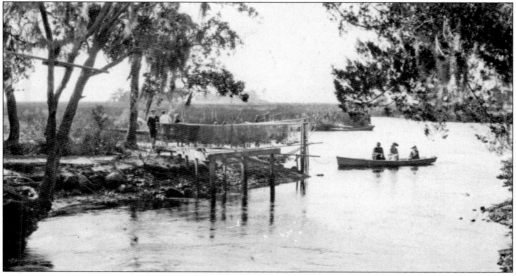

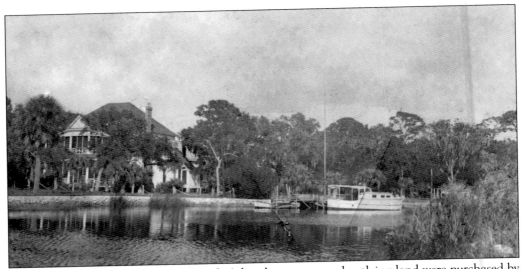

After sitting dilapidated, in 1926, Moseley's hotel, property, and outlying land were purchased by Montreal doctor C. J. Edgar, who had intentions of converting the old hotel into a premiere fishing and hunting lodge known as the Gulf Springs Lodge. As he was going ahead with plans, January 14, 1927, newspapers reported, "Work was progressing rapidly on the remodeling of the Gulf Springs Lodge in Hudson" as "workmen transformed the abandoned building into a most attractive lodge, a water system in which the town folks participated was installed and now a light system so that the doctor has made possible all city conveniences." While the lodge had accommodations of electricity and water, these services were exclusive. On February 27, 1927, the Gulf Springs Lodge opened for business. It was reported that "more than a hundred hungry folks were clamoring for dinner." (Above, Gerry Hatcher Dougherty.)

GULF SPRINGS LODGE

ON THE GULF
Hudson, Pasco County
Florida
.............MODERN...........

OLD AMERICAN HOSPITALITY
Canadian-English Atmosphere Maintained

Sunday Chicken Dinner
1:00 P. M.—$1.00

Special Week End Rate—$5.00 Single, $9.00 Double

SUMMER RATE FROM APRIL FIRST TO SEPTEMBER

FIRST—ROOM AND BOARD—$12.00 PER WEEK

Mr. and Mrs. Alf Kuhlman
Lessees and Managers

MAJOR C. J. EDGAR, M. D.,
——OWNER——

"The dinner was all they could expect with the day spent on the Gulf, or in delightful walks about the hotel," it was said. The lodge was leased each summer, by Mr. and Mrs. Frank Keene in April 1927 and Mr. and Mrs. Alf Kuhlman in April 1928. Among more notable guests to enjoy lodge accommodations was Louisiana governor Huey P. Long, who visited in April 1929 for a holiday of fishing and hunting. In 1930, the hotel came under management of S. A. Glass and James "Jimmy" Glass of Tampa, father and son. Glass hired Chinese chef Yep Wong, formerly of the Mikado Inn at Tampa, and meals were served by Francis and Bealee Hanington, husband and wife. The Glasses managed the hotel until it was destroyed by fire January 23, 1943, shown right and never to be rebuilt.

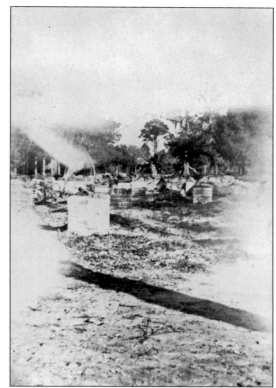

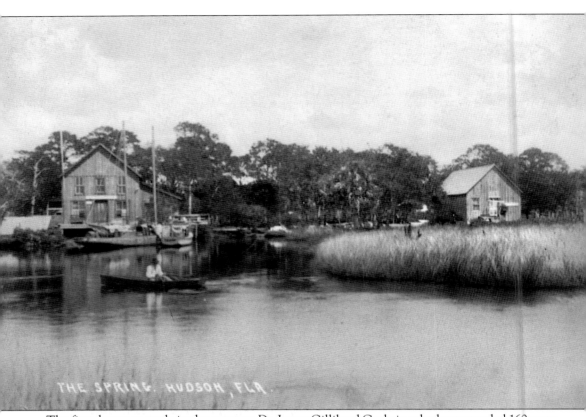

THE SPRING HUDSON, FLA.

The first doctor to settle in the area was Dr. James Gilliland Guthrie, who homesteaded 160 acres northeast of Hudson near today's Houston Avenue, as well as owning a house in town. Dr. Guthrie was born in 1840 in Pennsylvania to Nancy McLean and Thomas Guthrie, a Presbyterian pastor educated in medicine. James served as a Union nurse during the Civil War, afterwards furthering his education by earning a medical degree from the University of Pennsylvania and working for the U.S. government as a doctor. After settling in Hudson around 1883, he cared for the area's sick, working from his town home situated along Hudson Creek and today's Kulig Court. In 1888, Dr. Guthrie was joined by Dr. James Martin Posey, who established an allopath practice in Hudson, with a specialty in general surgery. James Posey was born July 29, 1866, in Aiken, South Carolina, to Lazirus and Sarah Posey. After his father's death, he furthered his education, attending Aiken Academy, South Carolina College of Columbia, Medical College of Georgia at Augusta, and finally graduating from University of Georgia Medical Department in 1889.

In 1892, Dr. Posey married for the first time and had two children, one dying young. By 1897, Dr. Posey was joined by Dr. George Goshorn, a druggist. The two doctors soon built Hudson first doctor's office and drugstore (shown here). Dr. Posey saw patients and wrote prescriptions that were filled by Dr. Goshorn, in the same office. This small building was located on the south bank of the big spring and at the end of Hudson Avenue, not far from Dr. Guthrie's town home. The drugstore was across the spring from Moseley's store and hotel, the two-story building, and Littell and Sons store on the north bank of the big spring (pictured on page 104). (Ann L. Knowles.)

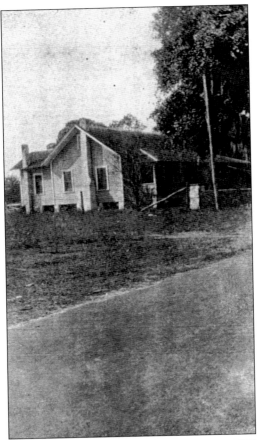

By 1900, Dr. Goshorn had enlisted with the army and Dr. Posey took over the drugstore entirely. It is said that Posey's drugstore was complete with patent medicines, including veterinarian supplies for local farmers. After taking over the store, he located to the home pictured here, on West Hudson Avenue just east of his drugstore and Hudson Spring. In 1905, James Posey married a second time to a Pauline T., but they had no children according to records. Dr. Posey was very well liked and admired by his patients and residents alike. In 1906, Dr. Goshorn returned, taking a position as postmaster. After the Fivay sawmills arrived to the area in 1908, it is said that Dr. Posey served as the mill doctor, working in the county's first community hospital, likely using his needed surgical skills.

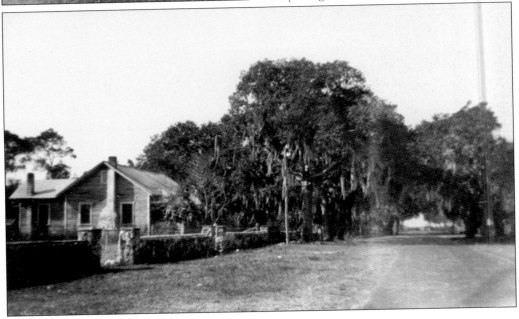

In February 1909, Dr. Posey was arrested for assault with intent to kill, a result of an altercation between a Mr. Ellis, who was attempting to sell property with a typhoid-contaminated well. After imprisonment in Tallahassee, he was sent to Ocala, being incarcerated in the Southern Prison, where he became the prison doctor and received a license August 5, 1911. While imprisoned, he remained in close contact with Rebecca Frierson Prichard, writing letters such as the one shown here, sent from time to time with medication for her. After being released, he returned to Augusta, Georgia, where he received another medical license on May 1, 1913. After a year, he returned to his patients in Hudson and received another Florida medical license on February 8, 1914. In January 1916, he moved to New Port Richey, renting a bungalow on Orange Lake and opening a practice above the Port Richey Drug Store. (Both, Claudia Rowe.)

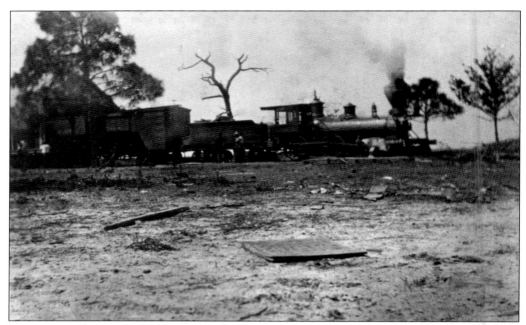

Surveyed by Henry Clay Bush and built to move early sawmill workers from Brooksville to the Fivay sawmills, the Brooksville-Hudson Railroad opened May 26, 1904, newspapers reported. Eventually the line was connected to the Tampa Northern Railroad. With the arrival of the railroad, a depot was constructed north of Hudson Spring and Gulf Springs Lodge. Above is the only known photograph of Hudson's depot, which is obscured behind the train and large pine trees. The train made two other stops while in town: McCreary's fish house along the creek, the location of Hudson's Express Telegraph office, and Corwin Pearl Littell's fish house at the end of the line (shown below). Here the narrow-gauge tracks, laid through the marsh, were raised upon wooden trestles above rising tides; however, with no turnabout, trains usually backed into town. (Above, Ann L. Knowles; below, Littell family.)

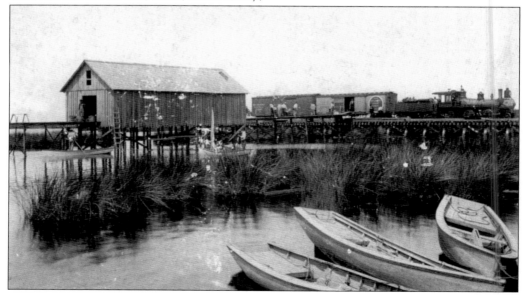

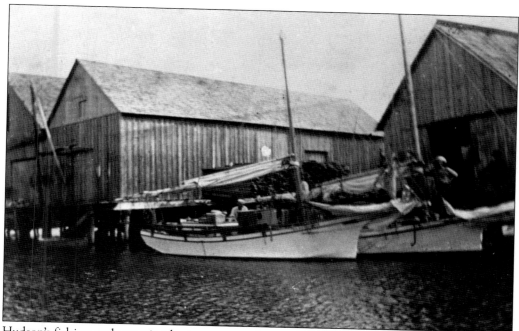

Hudson's fishing and sponging businesses were beginning to thrive, and the banks of the creek and spring were bearing the numerous warehouses. By 1915, Corwin Pearl Littell expanded his warehouse, incorporating another building, which became known as the Hudson Wharf and Dock, although there were no roads from the mainland. These buildings were placed at the end of the railroad spur and strategically located at the mouth of the creek so boats could easily access them without navigating the entire creek. The building had a large door at each end, one opening to the water and the other to the railroad tracks. After cleaning, fish were heavily salted, allowing for storage without refrigeration, a long-practiced method at the time. An alternative was to smoke the fish. (Above, late Marvin Henderson collection.)

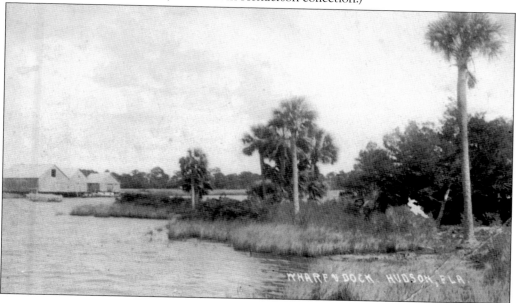

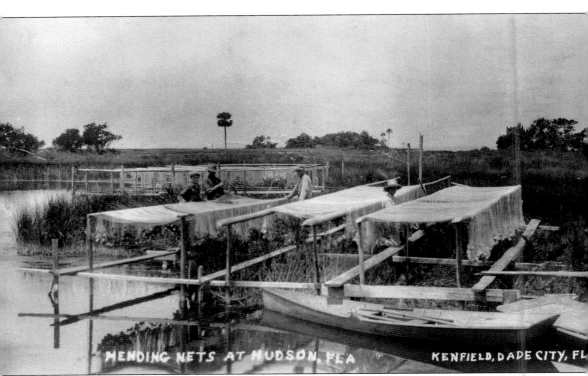

MENDING NETS AT HUDSON, FLA KENFIELD, DADE CITY, FL

With the warehouses along the banks of Hudson Creek came the addition of numerous net spreads, which were simple wooden frames where fishing nets could be spread for drying and mending. These spreads were built at the waters' edge, in the marsh grass, allowing the nets to be unloaded directly from the skiffs to the spreads. Around the bottom of the spreads was a platform to stand and walk on while working. Nets were handmade and repairs were done by hand, unlike the throwaway synthetic nets used today. The mending and making of nets was a unique trade that was taught and handed down from the previous generations. Here, from left to right, resident fisherman Salem Hatcher is teaching his son Zeno how to mend the nets with help from Will Hicks and Fred Pearce. The spreads pictured here, in the 1930s, were located on the north bank of the Hudson Creek, just west of the Gulf Springs Lodge. Notice again Cotton Island in the distance. (Late Raymond Knowles collection.)

The fish house pictured below, just west of the hotel, was owned by resident fisherman Jack Knowles, pictured right with two nice-sized grouper. Notice the seawall made of natural stone, added during the remodeling of the old hotel in 1927. In the early 1930s, this fish house became the principal business location for Jack's wholesale commercial fish market, which he named New Deal Fish Company. The New Deal Fish Company was one of three wholesale fish houses operating in Hudson throughout the 1930s and 1940s; the second was owned and operated by local fisherman Albert Hatcher and Walter Bliss, who were partners, and the third was operated by Michael Knowles Jr., who started his wholesale fish house in 1937. In 1938, there were so many orders for fish and sponges than these three fleets could not keep up.

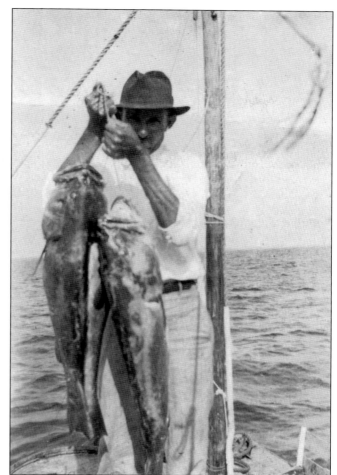

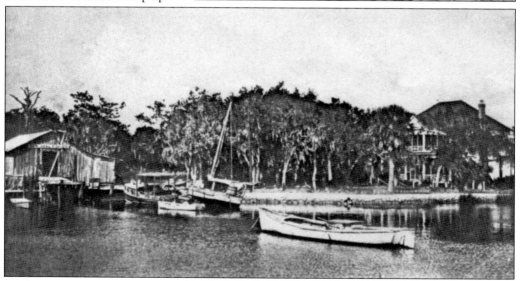

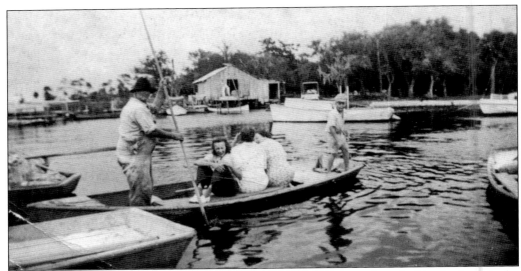

Here is Robert Knowles with his family poling across the spring and creek. On the far left, the net spreads are visible along the edge of the creek, in the center is the Jack Knowles fish house, and at far right is the natural stone seawall and hotel yard. Anchored about the spring are the various sponging and fishing vessels that used Hudson as their port, boats such as *Spirit of Hudson*, *Laura*, *Defender*, and *Mary Ann*. As early as 1899, residents worked to get the creek deepened by the Army Corps of Engineers to better serve the fleets. Hudson was the only Gulf Coast port and dock that did not have the damaging boat worm because of the fresh waters flowing from the Hudson Spring.

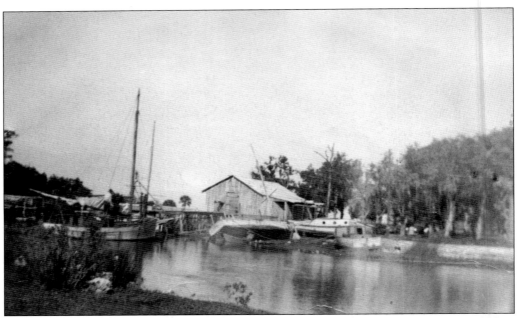

This fish house was also owned by several other local fishermen throughout its history, including J. L. Harrell and Claude Yeomans, who used it for their wholesale fish businesses. It was common to see several boats anchored along the creek and around the spring.

After losing the hotel, the spring became the place for community events. During World War II, residents wanted to recognize and honor their young men overseas. Corwin Pearl Littell donated time and materials building the memorial pictured. On July 4, 1944, residents gathered at the spring to dedicate their honor roll, finally placed at the post office. Next to the memorial are Amelia Lysek (left) and Hilma Sue Nelson Littell (right). Names on the memorial were Harold Billingsy, Wilson Billingsy, Elmer Brady, Berloy Booth, Goree D'Equevilley (Equevilley), Louis Fitzgerald, Harry Fortner, Bates Fletcher, Leroy Gillett, Wesley Gillett, Herschel Hudson, Gene Garris, Fred Kold, Kenneth Knowles, Willie Lovett, Henry Lysek, John Lysek, Thomas Lysek, Mayhew Littell, Sidney Littell, Tom Prichard, Wallace Todd, and Dan Yerke for service in the army; Bryce Bliss, Benny Booth, Logan Connor, Aaron Gillett, Zeno Hatcher, Lonzie Hatcher, Robert Hatcher, Marks Hatcher, Vernon Hudson, Almus Hamilton, Raymond Knowles, Martin Lysek, Frank Lysek, Joe Littell, George Lovett, George Pearce, and Adrian Roberts from the navy; and Worth Littell and Austin Rouru, marines. (Both, late Leona Knowles Kingsley.)

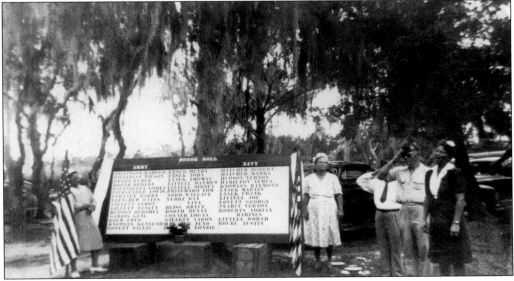

Pictured in 1978 is Hudson Spring 100 years after being settled by the Hudson family; notice the absence of boats and fish houses. After the Gulf Springs Lodge burned in 1943, the property was eventually subdivided into lots to become Hudson Spring Mobile Home Park. Throughout the 1950s, there were several developments underway, most involving extensive dredging and backfilling of marshlands. This major development era started in 1950 when W. L. Hendry came from Tampa with his sons Lawrence and Caleb, purchasing 60 acres west and north of Hudson Creek. This was one of the first dredging and filling projects as rock and sand were piled on the creek banks to create Gulf-front lots. With Old Dixie Highway and Hudson Avenue right of center, the 1957 aerial photograph below shows the extensive backfilling projects, evident from the fresh white dredged sand. (Below, author's collection.)

Seven

EARLY INDUSTRY AND AROUND TOWN

The early Hudson community was much larger than today and included areas as far north as the Sea Pines Subdivision, south to State Road 52 and U.S. 19, and extending east near Hudson Avenue and Hays Road. Today this is known as the Greater Hudson area until urban sprawling reduces the area through annexation. Historically Hudson was a fishing and sponging village, as residents mainly derived their livelihood from the Gulf waters, causing the town's commerce to be centered on Hudson Spring. Most "watermen" fished in the fall and winter while sponging in the spring and summer. While fishing and sponging were staple industries, there were several grocery/mercantile stores, boardinghouses, general farms, and other profitable businesses established throughout the area, including the numerous turpentine camps and sawmills.

While fishing is now thought to be a pleasurable recreation, the early fishermen of Hudson were hardworking and persistent in their labor. Working in crews, their fleets consisted of a small launch and several skiffs, each crew member with his own skiff. When a school of fish was sighted, the men worked together, staking the nets while circling the school, closing the net around them. The fish were then put below deck of the launch loaded with ice. Sponging was similar in the respect that there was a main launch with several skiffs. In the 1920s, the Hudson-Aripeka Board of Trade was established to promote the local industries. After World War II, these important industries were damaged by Red Tide and never fully recovered. Today there are few, if any, who fish commercially; however, there are those who do rely on the Gulf waters through shrimping.

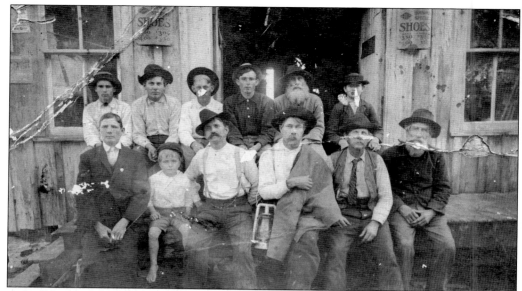

Often crews gathered at Littell Sons store, conveniently located near the spring where they could easily purchase provisions before setting sail. Pictured above from left to right are (first row) Bill Beard, Almer Overton, Woodson L. Overton (a pharmacist in the absence of Dr. Posey), Bill Eiland with the lantern, unidentified, and Joe Ingram; (second row) Willie Knowles, Tom Brady, Robert Henry Knowles, John "Jack" Henry Knowles, Michael Knowles Sr., and unidentified. Notice also the man standing in the left window, believed to be store proprietor Corwin Pearl Littell. Below is a group of Hudson's younger seafaring men dressed in typical winter attire and wooly over-shirts. While not everyone has been identified, Robert Henry Knowles is believed to be seated at back left. Teenage boys often assisted in the fishing expeditions of their fathers, learning important trade secrets handed down from previous generations. (Below, Ruth Conner.)

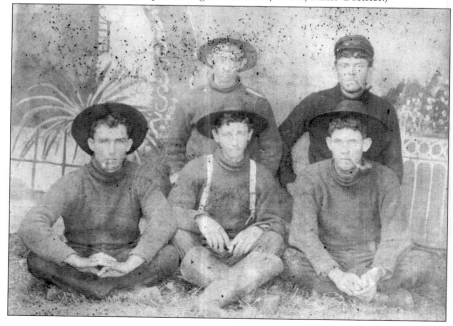

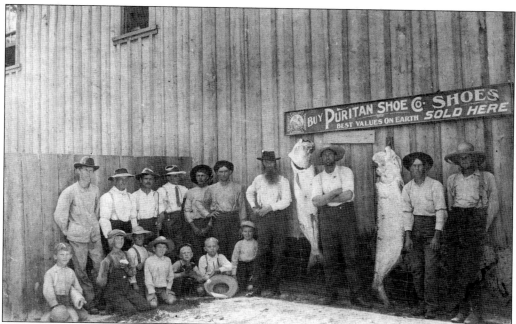

Not visible, the small sign reads, "Fishing at Hudson, FLA." Occasionally their best catch was displayed at the store, and certainly there were many good fishing stories, the tales of how the catch was brought ashore. Pictured are (back row) Eugene Carter, Robert Henry Knowles, unidentified, James Franklin Gillett, John Olan Hay, Woolsey Samuel Knowles, William Hankinson Nelson (who operated the store), store owner Corwin Pearl Littell, Louis Hancock, and John Alexander Brady III. Bartow Littell has been identified in the overturned hat; others are unidentified. There were many different stores throughout Hudson's history. Below is the Homers C. Henderson Store around 1905. Parked in their buggy are John Tayor and Johanna Duet Bellamy Frierson with their children, while store proprietor Homer Hendeson steadies their horses. Other prosperous stores included Moseley's, Hudson-Briana's, Lewis', Vinson's, Payne's, Guthrie's, and Fitzgerald-Hatcher's, to name a few. (Below, Bernice Baker Mills.)

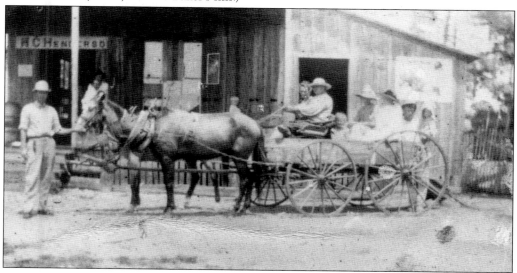

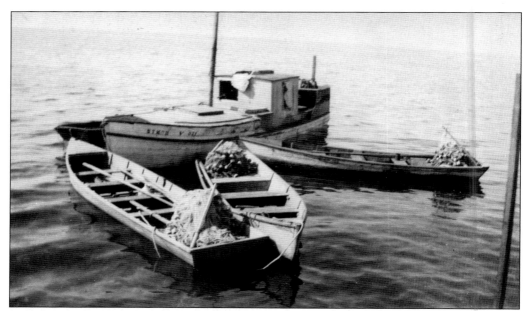

Pictured above is a typical fleet launch operated by Robert Henry Knowles, John Henry "Jack" Knowles, Michael Knowles Jr., and Walter Gause, pictured below. Each crew member typically had his own skiff; if not, the crew poled out together, staking and setting their gill nets. The launch had a large box filled with ice where fish were stored. The smaller box was used for the storage of food supplies, water, crew provisions, or for getting out of the sun if needed. Spending time on the water meant crews often spent their downtime atop the main launch, catching a nap or having a meal. This series of photographs offers a rare glimpse into life on the Gulf waters as the crew spends a few minutes of their day grabbing a bite to eat atop the main launch. (Gloria Surls.)

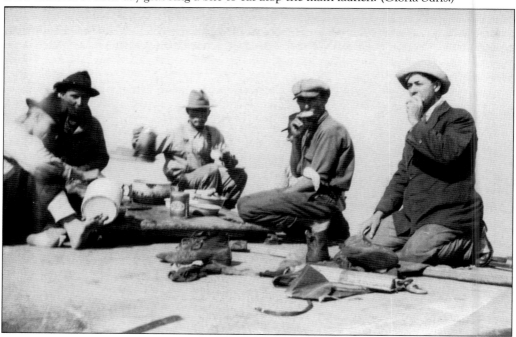

After sighting a school of fish, crews worked to circle the school and close the nets. Once their skiffs were filled, they poled back to the main launch to unload. The skiffs pulled alongside the launch, and each crew member unloaded his catch by hand, as shown left. This process was repeated until the main launch storage was filled or provisions ran low, whichever came first. After returning to port, the men unloaded their catch and restocked with provisions in preparation for their next trip. Today gill nets have been banned, destroying the livelihood of these early pioneers. Along with the industry, not only have the historic net spreads that once made Hudson's staple industry been lost, but the trade secret of making and mending gill nets by hand is also lost—secrets passed from generation to generation. (Gloria Surls.)

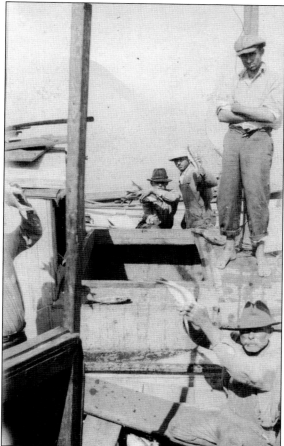

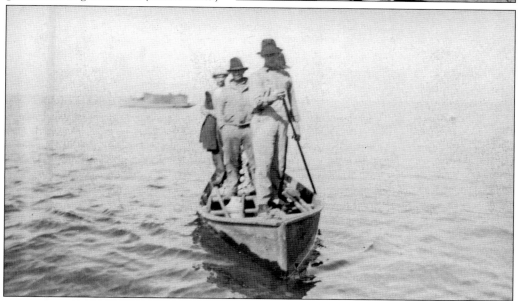

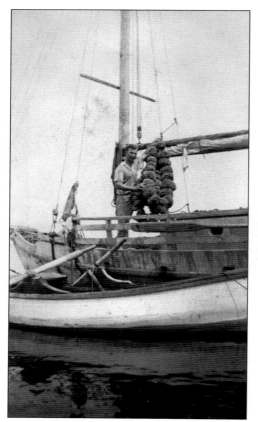

Sponging fleets also used a main launch and utilized skiffs while using glass-bottomed buckets to look below the water surface, pulling sponges from the rocky bottom with long pole hooks, filling their skiffs, and afterward returning to the main launch. Below are Henry, Martin, and Thomas Lysek standing aboard their fleet, the *Spirit of Hudson*, built by their brother Frank. Cutting the best virgin pine found near today's Lakeside Woodland's Subdivision on Fivay Road, after months of sawing, bending, molding, and crafting, they completed their vessel but it still had to be carried to the water from the Lyseks' farm nearly 2 miles away. With rollers, the boat was rolled to the Gulf to begin her life. The Lysek boys used both the pole hook method and modern diving methods to bring their sponges ashore. (Both, Hilma Lysek Tracey.)

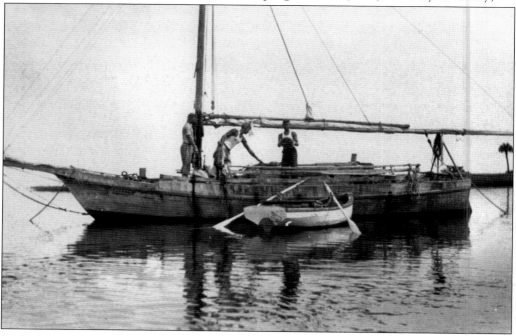

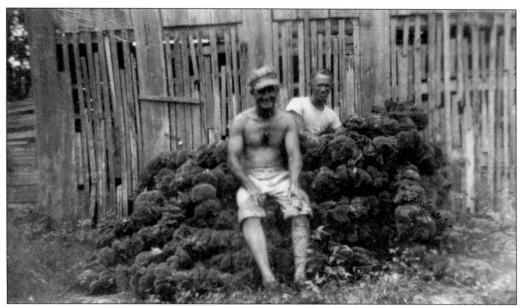

Most fleets were on the waters year-round, fishing in the fall and winter and sponging in the spring and summer. Some men found mainland employment such as farming or road work or with the local sawmills during winter. Proudly sitting in a pile of fresh dried grass sponges are Kenneth Knowles and Dillon Sigmon (wearing a hat). The crudely constructed building was used to dry their sponges before selling them at market. The building had several storage cribs that had open slats on the doors. After being cleaned, the sponges were put in these bins to air dry, with the valuable catch secured behind locked doors. Each fleet was responsible for cleaning, drying, and storing their sponges. This particular storage shed was located behind the Knowles home on Hudson Avenue, approximately 150 yards east of Hudson Spring where their fleets were anchored.

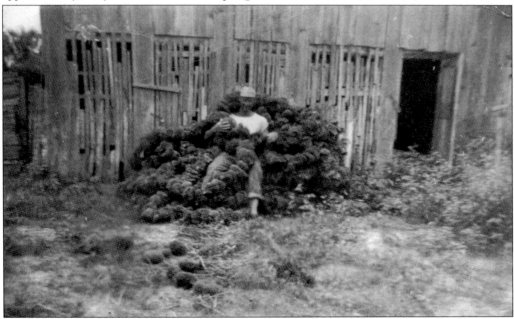

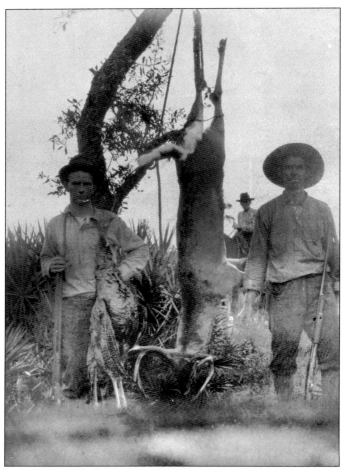

Some worked as hunting and fishing guides. Among these early guides were the Carter boys, Eugene, Henry, and Charlie, some of the best in the area. The photograph below taken at the Carter home shows one of their many successful guided hunting trips. Pictured from left to right are Eugene and Nettie Carter, Dr. Matthews (from Largo), Charlie and Henry Carter, and (kneeling) Dr. Matthews's unnamed partner. Through the years, the Carters became good friends with Dr. Matthews. Upper left is Eugene Carter with a 125-pound buck that he shot with his young friend, with whom he served during World War I. His friend bagged a rather large turkey, which Nettie cooked for dinner that night. Today very little wildlife remains along the coast and hunting is prohibited because of the numerous subdivisions and population. (Both, Carter family collection.)

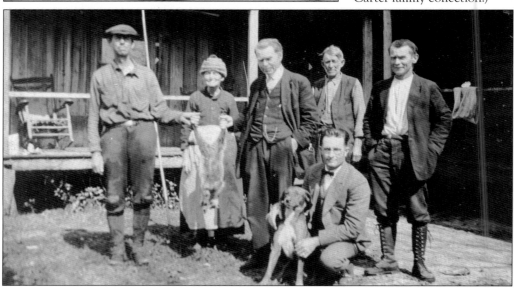

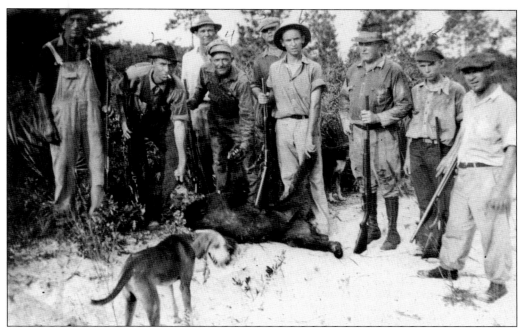

Wildlife was abundant throughout the area. Residents who did not hunt and fish for a living often enjoyed doing so as recreation or to gather food. Above is a group of local residents who bagged one of the many black bears thriving near Fillman's Bayou; identified are, from left to right, J. B. Kolb, Eugene Carter, Romaine D'Equevilley (Equevilley), Henry Norfleet, R. E. Baillie, and his son Roy Baillie. Today few black bears survive not because of hunting but because development and lime rock mining have destroyed their pristine habitat; what little remains might be destroyed during future development. Pictured below is Corwin Pearl Littell with a group at Fillman's Bayou for a day of cane pole fishing, likely before days of rod and reels. Today both images will remain historic as these activities are no longer permitted. (Above, Carter family collection; below, Mayhew E. Littell collection.)

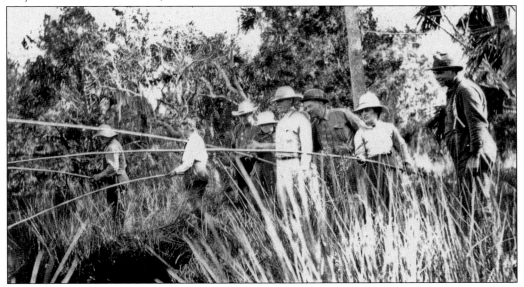

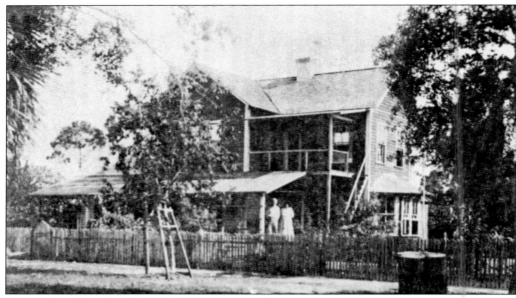

Hudson's first boardinghouse was constructed by Rev. Joseph Smith, who was born June 10, 1848, in South Carolina. A Confederate veteran, around 1904, Joseph moved to Hudson, building the large home and boardinghouse pictured. On June 27, 1906, he was appointed postmaster, building a new post office west of his boardinghouse at today's Kulig Court and Hudson Avenue. In 1908, at age 60, he married 23-year-old Florence Robinson Russell, the second marriage for both. As a Baptist minister, in 1914, he aided in the construction of New Port Richey's first church, consisting of a platform, pulpit, and seats along the river. In later years, the Smith home was owned by Jimmy Glass, manager of the Gulf Springs Lodge. In April 1965, the grand home was destroyed by fire. (Above, late Ruth and Willie Knowles collection.)

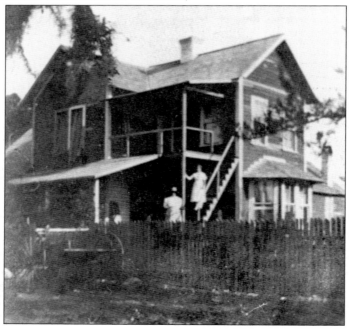

In 1909, Edward Leopold, after acquiring the property from previous owner Mr. Russell, began construction of his two-story home situated along the railroad tracks north of town at today's Stevens Drive and Old Dixie Highway. The home, pictured, was complete with a cupola overlooking the Gulf and named the Kentucky Inn to honor the state where Edward had previously lived. Recent research also indicates it was called the Ohio House by Elizabeth Leopold, pictured next to the car driven by Emma Knowles Brady. The inn was a type of port house on the road from Hudson to Aripeka, with Elizabeth serving hot meals to guests who sought overnight lodging. In 1943, Salem and Eda Hatcher purchased the home, making it their own. In the early 1990s, the home was also destroyed by fire. (Below, the Hatcher family.)

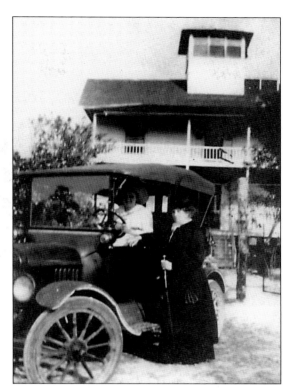

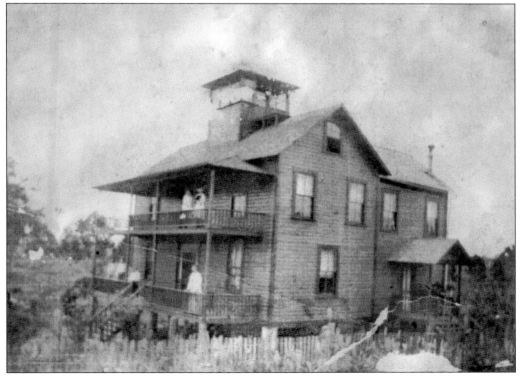

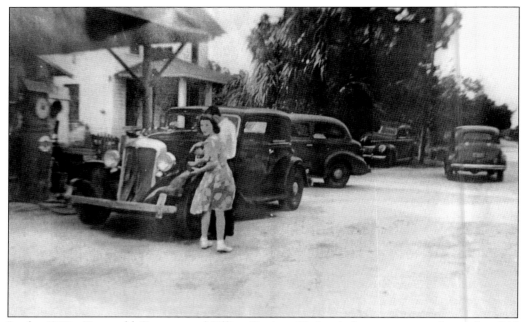

In the 1920s, Fitzgerald Grocery and Filling Station, Hudson's first gas station, located at Old Dixie Highway and Harbor Drive, was opened by Henry Fitzgerald, who later sold it to Albert and Fannie Roberts Hatcher. The Hatchers lived in the two-story home next door; the April 1944 photograph above is the only known image of the store. Tuesday, February 5, 1952, at about 9:30 p.m., the home caught fire and the family lost everything. The store was slightly damaged; however, it had already been moved to the southwest corner of today's Hudson Avenue and U.S. 19. The Hatchers' new store, below, was constructed of cinder block and in 1957 was the location of the New Port Richey rural post office substation for Hudson. They later sold the store to their daughter Johnnye and son-in-law Mike Sanchez, who named it Sanchez Market. (Above, Ruth Conner; below, Geraldine Hatcher Dougherty.)

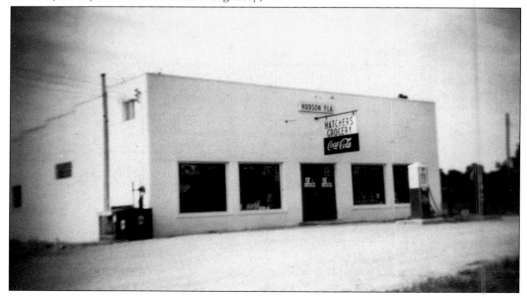

The U.S. 19 traveled today was not known to Hudson's earliest settlers and did not exist until 1951; residents traveled the road now known as Old Dixie Highway. Originally constructed by Col. William Davenport in 1837, the road stretched from the Chassahowitzka to Anclote Rivers, later becoming the main road along the coast. The section north of Hudson became commonly called the Hudson-Aripeka Road until becoming part of the National Automobile Trail and planned U.S. automobile highway in 1914, called the Dixie Highway and overseen by Dixie Highway Association. Work to improve Dixie Highway through Hudson began in 1922 as reported by the *New Port Richey Press*. In 1927, the Dixie Highway Association disbanded, with their road becoming a U.S. Highway. Today's U.S. 19 through Pasco County, constructed in 1951, is considered the most dangerous road in the United States. (Below, Ruth Conner.)

Making The New Road

The work of rebuilding the hard road, or Dixie Highway, from New Port Richey north to the county line is now under full swing, and is proceeding at a rapid rate. The stone crusher has been temporarily located about six miles from town, just this side of Hudson, and six big trucks are hauling rock to put on the road. Mr. C. Johnson is in charge of the work which is being done under the supervision of O. W. Bache, State Road Engineer. The road is being built 16 feet wide, and is as smooth as a floor. This strip of road is an important link in one of the three great State highways projected and now under construction by the State Highway Commission.

www.arcadiapublishing.com

Discover books about the town where you grew up, the cities where your friends and families live, the town where your parents met, or even that retirement spot you've been dreaming about. Our Web site provides history lovers with exclusive deals, advanced notification about new titles, e-mail alerts of author events, and much more.

Arcadia Publishing, the leading local history publisher in the United States, is committed to making history accessible and meaningful through publishing books that celebrate and preserve the heritage of America's people and places. Consistent with our mission to preserve history on a local level, this book was printed in South Carolina on American-made paper and manufactured entirely in the United States.

This book carries the accredited Forest Stewardship Council (FSC) label and is printed on 100 percent FSC-certified paper. Products carrying the FSC label are independently certified to assure consumers that they come from forests that are managed to meet the social, economic, and ecological needs of present and future generations.

FSC
Mixed Sources
Product group from well-managed forests and other controlled sources

Cert no. SW-COC-001530
www.fsc.org
© 1996 Forest Stewardship Council

Find Your Place in History.